LIVING YOUR ART LOVING YOUR LIFE

101 DAILY REFLECTIONS
ON YOUR ARTISTIC GIFTS

BY ALFRED J. GARROTTO

WLM BOOKS

D1096875

LIVING YOUR ART — LOVING YOUR LIFE

First Edition

ISBN: 9798391686118

TABLE OF CONTENTS

Dedication

I dedicate this book to all the amazingly talented people in the Arts, those who have achieved what most of us call "success" in their field and those talented people who produce great art but as yet not reached broader audiences. You are among the most important people on the face of planet Earth. Yours is the gift of creating the beautiful environs and entertainment so essential to our quality of life on planet Earth.

FOREWORD

I offer this book as my gift to you. I intend it to apply to any and all artistic gifts. It comes with my prayerful hope that each day's message will inspire and lead you to deeper appreciation of your talent and provide needed nourishment to continue on your journey, wherever it takes you.

The design and layout of this book features 101 short reflections on your personal artistic gifts... whatever they may be. Ideally, your greatest benefit will come not just from reading but also—and more important—from connecting what you've read with your day-to-day experience of plying your craft.

In writing this book, I aim to offer inspiration to engage the broad spectrum of talented writers, actors, composers, dancers, musicians, fine artists (across the broad spectrum of graphic arts), et al. Talented men and women of *all* ages, nationalities, and personalities offer a broad range of expressions within the collective human imagination. Within each artist's area of giftedness lies a unique vision and expression of the state of our world in the present moment... and what that world landscape may become for you in the future.

You will gain the most benefit by relating each reflection to your unique gift(s) as you spend time each day pondering these brief moments of enlightenment.

How much time? That is up to you. I intend the reflection questions at the end of each day to spark helpful insights that will feed and enhance your growth as an artist. These questions invite you to internalize what you've just read. Doing so will foster greater understanding of your personally satisfying—and often mystifying—artistic gifts.

In some cases, the time you spend may last no more than a few minutes. On other days, you may find yourself dwelling longer as you allow the message to sink deeper into your artistic spirit. As you ponder each question, let your mind and spirit roam freely. Give yourself permission to internalize the message, always asking yourself, "What does this mean to me in my field of the arts?"

In these pages I also include and salute all creative inventors and dreamers who design and produce the life-enhancing products we use daily—and take for granted. You and your creative brothers and sisters bear the gifts of inventiveness and ingenuity to enhance the lives of countless people. I pay homage to you all for your contributions to the betterment of our world.

As you set out on this journey into your inmost being, I offer John O'Donoghue's inspiring words in *Beauty: The Invisible Embrace*—

"The imagination retains a passion for freedom. There are no rules for the imagination. It never wants to stay trapped in the expected territories. The old maps never satisfy it. It wants to press ahead beyond the accepted frontiers and bring back reports of regions no mapmaker has yet visited."

Day 1

Art ... a Path to the Divine

"Art can be another path to God. Art can be another kind of food that helps people to thrive."
— Jessica Mesman Griffith, "Building the kingdom with pencil and paper," *US Catholic* article

Throughout these reflections, you will find the term "Creator-Spirit" referring to the divine source of all artistic gifts and creative expression. "Creator" speaks to the *outward* manifestation of your art. We call the first material expression of art... the "Big Bang."

Let "Spirit" remind you that, in all realms of existence, you immerse yourself in an indescribable mystery. To enter these realms, you need spiritual vision beyond the capacity and function of your physical eyes to penetrate the "why" of the created universe and your unique place within it.

Reflect

How might I apply Jessica Mesman Griffith's insight to my own life and work?

How challenging... or inspiring is it for me to think of my art—any art—in terms of "another path to God" or a "kind of food that helps people to thrive"?

Day 2

What It Means to Create

"In the beginning...." Book of Genesis 1: 1

Whoever wrote the first twelve chapters of the Book of Genesis as we know them in the bible today wasted no time.

All civilizations from prehistory to the present have felt the need for a "creation story." This arises from a fundamental human need to explain where we came from, how we got here... and the meaning of our being here amid the ongoing human story.

In the Hebrew Scriptures, the creation story begins in the *first* line of the *first* chapter of Genesis, the *first* book of the Bible. Immediately, we get caught up in the imagery of story and poetry to explain the otherwise unexplainable. The Hebrew biblical author(s) grappled with a growing mound of night language questions.

Some-thing from *no*-thing?

What might that mean in human terms? Why did Creator-Spirit, the master artist and designer of the Universe, decide to create *anything*? And why humans?

Day language—the normal speech we use to communicate with others—cannot answer these questions.

As an artist, you identify as a "creative" person. But what does that mean? Can you legitimately claim the title, "co-creator" with Creator-Spirit?

Consider this statement in an article by art critic Charles Desmarais in the *San Francisco Chronicle*, "Waters remodels our home" (April 16, 2016). Architecture is "an alternate realm, artificial by design. It is the place we have made out of objects we had to create, because they did not exist."

Hmmm. Sounds a lot like the first chapter of Genesis.

Reflect

*How strongly do I believe that my work as an artist—
in whatever field of the arts—must come to being,
because no one else can create exactly what I create?*

*What role does "fame/public recognition" play
in my standard for the validity of my art?*

*How prone am I to judge the value of my art using
the arbitrary—and fickle—standard of "fame/public
recognition"?*

DAY 3

DAY LANGUAGE

"...the language of science, Western medicine, mathematical fact, historical proof, business, techno-logy.... [Day language] expresses "what is," primarily in a material, physical sense."
— Michael Dowd, *Thank God for Evolution*

In his challenging book, Dowd identifies the polar opposite manifestations of communication in terms of "day language" and "night language." Day language expresses the "what" of the universe. It cannot help you to grasp the ultimate meaning, the *"why,"* of the universe... or the *"why"* of human body-spirit existence.

Referencing Matthew's Gospel (13: 14-15), Christian Wiman writes in *My Bright Abyss*: "[Jesus] speaks the language of reality—speaks in terms of the physical world because he is reality's culmination and key... and because 'this people's mind has become dull; they have stopped their ears and shut their eyes. Otherwise, their eyes might see, their ears hear, and their mind

understand, and then they might turn to me, and I would heal them.'"

Your ability to believe in a reality you cannot see... touch... smell... taste... or experience in any physical manner can only come from a source higher and outside of yourself. But that source patiently waits—now and for however long it takes—for you to acknowledge it.

Reflect

What would my life be like if only "day language" existed?

How would a totally "day language" existence change my life as I know it today?

DAY 4

NIGHT LANGUAGE

"It is vital to remind ourselves, from time to time, of two complementary sides of the one coin of our experience. On one side is the realm of what's so: the facts, the objectively real, that which is publicly and measurably true. Let's call this side of reality our day experience. We talk or write about it using day language—that is, normal everyday discourse.

"The other side of our experiential coin I call night experience. It is communicated through night language, by way of grand metaphors, poetry, and vibrant images. Our attention is focused on 'What does it mean?' This side of our experience is subjectively real, like a nighttime dream, though not objectively real. Night language is personally or culturally meaning-ful. It nourishes us with spectacular images of emotional truth."—Rev. Michael Dowd, *Thank God For Evolution*

Unlike those who live most of their daily lives immersed in "day language" jobs and tasks, you have chosen as an artist to harvest the gifts of what Dowd calls "night language."

This other language offers insight and an otherworldly vision, even if for short periods of time. That decision enables you to live in *both* worlds. Some type of daily work must be done or you might risk starvation, shattered relationships, and other undesirable out-comes.

Those who have not yet discovered the existence and value of "night language" sink into a form of half-life that you (thank God) avoid. You choose to be a *whole* person, rather than someone who works year after year at a repetitive, mind-numbing job.

I think of my own father as an example of living in both worlds. During the day he worked on the assembly line of a factory. As soon as he arrived home, he put on a new persona, becoming the general manager of a "minor league" opera company.

Being a gifted practitioner of night vision does not exempt you from "day language" activities and obligations. Like my dad, you have found a way to bridge the physical and mystical worlds. While your heart longs for more time to hone your craft and share the fruit of your talents, you face the truth that few artists can support themselves and meet their family's needs by applying their artistic talents full time.

Like most other artists, you struggle at times to find time for the application and mastery of your art... while meeting your primary obligation to support those who depend on you.

The blessing of your talent is that—rich or poor, recognized or not—you never lose your inner drive to create something of intrinsic value... something that never existed before.

From the depths of your being, you hear the call to retreat from your day-life into the realm of "night language," thereby satisfying that vital part of your true self. Within that mental and emotional space, you can experience the most satisfying inner peace.

Reflect

How aware am I that my artistic endeavors bring joy and deeper understanding to grateful people I may never meet at any time in my life?

How much satisfaction do I get from knowing my work can make life better for someone?

Day 5

Day-Night Crossover

"We live on this speck called Earth. Think about what you might do, today or tomorrow and make the most of it.... I think of space not as the final frontier but as the next frontier. Not as some-thing to be conquered but to be explored.... Not only do we live among the stars, the stars live within us." — Neil Degrasse Tyson, Astro-physicist, planetary scientist, and author

Like everything else in life, definitions have limitations. This happens when "day language" and "night language" collide in the same instant. Tyson breaks the mold as an example of day-night crossover. He makes it impossible to separate Tyson the scientist from Tyson the philosopher and dreamer. From all appearances he lives simultaneously in a middle realm in which day language and night language rub elbows. This happens even within the same moment as he speaks. Tyson offers a perfect example of the artist-scientist, one who does not switch

back and forth but lives simultaneously in multiple worlds.

Reflect

Besides Neil Degrasse Tyson, whom else do I know personally or elsewhere whose life and work cross barriers of day and night language?

To what extent, does this day-night collision occur in my own life?

Day 6

"Art"... Who and What are You?

"A bell is no bell till you ring it,
a song is no song till you sing it,
and love isn't love till you give it away."
— Richard Rodgers and Oscar
Hammerstein, *The Sound of Music*

Like love, art does not become art until you give birth to it, nurture it, and give it away. Did you just hear musical echoes? With wonderful simplicity, those well-known lyrics expressed a simple truth. "Art" covers a wide and diverse range of human activities. It plunges you into the pool of *outward expression* of your gifts and talents. "Art" is a noun but, in a poetic sense, it might serve us well as a verb—in the same way that 'love' is both a noun and a verb.

To put this another way, art cries out for expression in some form, even if your work never reaches public display and recognition in any published or reproduced format. Art finds its verification in its very existence... in your creative mind... in the external life you give it...

when you release your piece of art into that vast expanse we call "our audience."

Two millennia past, Jesus' told one of his timeless stories... the parable of the sower (Matthew 13: 1–9, 18–23):

"Listen! A sower went out to sow. And as he sowed, some seeds fell along the path, and the birds came and devoured them. Other seeds fell on rocky ground where they did not have much soil. They sprang up quickly because the soil was not deep. But when the sun came up, they were scorched, and because they did not have sufficient root, they withered. Still other seeds fell among the thorns that grew up and choked them. And others fell on good soil and produced grain, some a hundred times as much, some sixty, and some thirty. The one who has ears had better listen" (New English Translation).

Your creative gifts come to you as individual seeds scattered among the human race and planted deep in the fertile ground of each artist's being, primarily for the enhancement of others' lives. This doesn't mean you cannot enjoy your gifts and use them for your own private joy and entertainment. Your talent and its very existence make our world a better home for everyone.

That said, you must understand that your artistic gifts come to you with an invitation to share them with others. Self-satisfaction plays an important role in honing and perfecting your craft, but the broader picture of your gifts yields to the greater good of others. Creator-Spirit willed to manifest the beauty of divine presence in every corner of the Universe... and in the spirit of every human being on Earth. Nineteenth century preacher and abolitionist Henry Ward Beecher expressed this concept

in poetic imagery: "Every artist dips his brush in his soul and paints his own nature into pictures."

Reflect

In what ways do I outwardly express my art?

"Dipping my brush in my soul and painting pictures...."
What does this image mean to me?

Whatever my artistic gift(s), how do I "paint pictures" to brighten my world today?

Day 7

Can I Call a Work-in-Progress "Art"?

"Experts do not post exact rules, and the layman is apt to fall back upon his final line of defense: 'Well, I don't know anything about art but I know what I like.'"
— Eric Newton, *The Artist and His Public*

At what point in the creative process does a "work of art" earn that hallowed title? In other words, when does your initial creative spark—the internal linking of pieces and parts into a whole—evolve into a work of art? Must you withhold the title, Work of Art, until you see your finished product?

The 2016 exhibit, *Unfinished: Thoughts Left Visible*, at New York's Metropolitan Museum of Art provided a real-world answer. The show featured over one hundred and seventy unfinished works dating from the Renaissance to the present. The collection posed a question critical to artistic practice: Along the evolving creative process, when can you declare your work "art"?

Do never completed or unfinished pieces merit the title art? The Met's curators thought so. The broad world of the arts canonizes an artist's *concept*. Therefore you have every right to call your as yet unfinished pieces... works of art.

Reflect

To what extent do I agree or disagree with the Met's curators that an unfinished piece still merits the title, " a work of art"?

What unfinished works await completion within my studio... office... or the depths of my computer?

Even if I have judged one or more of my works not worthy of completion, how has this reflection changed my attitude toward my abandoned works?

DAY 8

SEEING IN THE DARK

"Only the artist can see in the dark."— Rev. Brian T. Joyce, late Pastor of Christ the King Church, Pleasant Hill, CA

Night vision is a gift bestowed upon every artist. Among all humanity, artists best comprehend the difference between "seeing" and "perceiving." Every sighted human can *see*, but a not-seeing darkness and blindness pervades the human spirit. That internal darkness whispering, "Don't believe this," has little to do with your brain's ability to communicate electronically with your optical nerves.

Jesus of Nazareth understood this better than anyone. That's why he taught primarily through the medium of art we call story. The New Testament refers to story in the gospels as "parable"—meaning a simple story intended to provide a profound lesson or teaching. In his teaching method, Jesus bypassed—without dismissing—the facts of history and physical science. In a passage from the

Gospel text of Matthew (13: 10-17), Jesus explained this dynamic of seeing in the dark:

"[Jesus'] disciples came to him with the question, 'Why do you speak in parables?'

He answered, "To you it has been given to know the secrets of the kingdom of heaven, but not to these people. For the one who has will be given more and he will have it in abundance. The one who does not have will be deprived of even what he has.

"That is why I speak to them in parables, because they look... and do not see; they hear... but they do not listen or understand. In them the words of the Prophet Isaiah are fulfilled: 'Much as you hear, you do not understand; much as you see, you do not perceive. For the heart of this people has grown dull. Their ears hardly hear and their eyes dare not see.... But blessed are your eyes because they see, and your ears, because they hear.'"

Reflect

How aware am I as an artist that I have the special gift of seeing what others do not see, hearing what others do not hear?

What obligation does my 'seeing' and 'hearing' impose on me to let my art "give sight to the blind"?

Day 9

The Language of Art

"All professions, all work, all activity in the human world finds its essential meaning in the context of a people's cosmic story."
— Brian Swimme, cosmologist, co-writer and host of the documentary film, *Journey of the Universe*

In an insightful book, *Thank God For Evolution*, theologian and evolutionary cosmologist Rev. Michael Dowd offers a helpful explanation of the power of art. Mystical truth appears and communicates with us through what Dowd calls "night language." It does this by way of poetic metaphors, vibrant images, and music. When you become aware of it and let your attention focus on it, you wonder, "What is this new mode of speech and communication saying to me."

The amazing power of the Arts derives from its ability to bridge the artificial, self-constructed divide between the realms of spirit and flesh. In doing so, night language

offers access to both sides of reality. But first, let's define the term.

"Night language" refers to myth, fiction, dance, music, poetry, art, dreams, storytelling, and other lines of human communication. It plunges you, the artist, into that deepest of all mysteries—your own human nature and the nature of your Creator-Spirit.

For Dowd, this side of experience deals in *subjective* reality, as experienced in sleep dreams. What you dream when asleep contains truth *for* and *about* you—your feelings about life, your fears, what makes you happy and what fuels your darker concerns and instincts.

"Though it is not *objectively* real," Dowd writes, "night language is personally or culturally meaningful. It nourishes us with spectacular images of emotional truth."

Reflect

How much attention do I pay to my night dreams?
How much importance do I give them as an integral part of my life as an artist?

When have I awakened from a sleeping dream with the kernel of a book, work of art, or previously uncomposed piece of music?
How seriously did I take that revelation?

Which of my already existing works of art derived their initial inspiration from a night language experience?

DAY 10

TRUST YOUR IMAGINATION

"An endless sea of ideas constantly flows around our planet, streamlining inspiration, fueling the minds of entrepreneurs, ultimately driving progress and innovation.... What lies beneath is the blueprint of inspiration, desire, and imagination."
— Anastasia Haralabidou from an online article, "Great ideas of imagination are more important than knowledge."

If you ever feel depleted of ideas for a creative project, try tapping into Anastasia Haralabidou's vision. How? Open your mind and heart to that "endless sea of ideas [that] constantly flows around our planet." You have the privilege of living in a universe that never runs out of creative seedlings. The key question for each of us: "How do I tap into that 'endless sea of ideas.'"

How can your drained mind and heart cast their nets into that immense pool of creative possibilities? Asking,

"How?" puts you at the wrong starting point. Better to ask the more helpful and challenging question, "When?" When will you plunge into that sea of life and feed upon what you once considered a Dead Sea, a teeming burial site of your creative gifts?

In the Acknowledgements pages of her novel, *A World of Curiosities*, an Inspector Gamache mystery, Louise Penny writes: "I want to return to the question of where I get my ideas for the books. ...I honestly don't feel I can take full credit for the books. There is, finally, an element of magic, of inspiration that seems to come out of nowhere."

If you need some triggers to get you started, begin by listening to conversations that go on around you.... Pay attention to both your day and sleep dreams.... Keep a journal to record seminal ideas that pop into your head. You needn't record full sentences. Pay attention to conversations you hear or overhear. These avenues provide triggers and voices comprising the raw material to get you started.

As an artist, you harvest the words and visions that come begging for expression as a song, a book, an article... whatever your personal art form. This harvesting provides the food your creative self craves and feeds on. Your privileged calling is to give them new life through your Creator-supplied giftedness.

Reflect

What did I dream about last night?
If I can't recall, then what is the most recent dream
I can remember?

What application did that dream have to some part of my life… my art?

What creative thoughts came to me in my waking hours today?

How have I harvested these free creative gifts for later expression through my art form?

Day 11

Passion or Curiosity?

"The definition of passion is an interest that you chase obsessively, almost because you have no choice.... I don't sit around waiting for passion to strike me. I keep working steadily, because I believe it is our privilege as humans to keep making things for as long as we live, and because I enjoy making things. Most of all, I keep working because I trust that creativity is always trying to find me, even when I have lost sight of it...." — Elizabeth Gilbert, *Big Magic*

Do I keep looking (waiting) for passion to grab hold of me when planning my next work of art? Gilbert cautions artistic people to give passion a secondary place to... inspiration. A flash of inspiration triggers your creative curiosity. Your mind whispers, "I wonder why...?" Inspiration doesn't demand your attention, it just won't rest until you take the next step.

Gilbert uses her New Jersey home and its garden as an example. Earlier in her life she had no interest in gardening or plants. Her mother did, but Elizabeth shunned it during her formative years. Then, one day she looked at some flowers growing in the back yard of her home. She wondered, "What's the story behind these flowers?" This led to trips to a library where she became fascinated with her plants' long journey from their places of origin scattered across the globe. Before she knew it, she had traveled to these places and taken notes. Not until she returned from her travels did she get an idea for a novel around the exotic origins of plants. This resulted in her 2013 novel, *The Signature of All Things.*

The moral of this story is to let your interests and curiosity guide you from project to project. And don't put too much emphasis on waiting for passion to drive you into a frenzy. Passion by itself will only keep you up nights as you try to chase it down rabbit holes.

Reflect

What is my own history of passion versus curiosity as guides to my career?

Where have I been spending my energy in the search for my next book, song, film, play, work of art...?

How much do I trust my curiosity as a prime factor in my creative choices?

DAY 12

THE GREATEST STORYTELLER

"Jesus speaks in stories as a way of preparing his followers to stake their lives on a story, because existence is not a puzzle to be solved, but a narrative to be inherited and undergone and transformed person by person." — Christian Wiman, poet and editor of *Poetry* magazine

With characteristic wisdom and spiritual insight, Wiman probed the reason why Jesus chose story as his primary vehicle for sharing his "Good News" with anyone who would listen. Jesus demonstrated the fine art of powerful, multi-layered storytelling. He expressed that gift by spinning a variety of tales designed to teach his audiences about the loving nature of his Father, whom he called *abba* (Daddy) in his Aramaic Hebrew dialect. He employed human words, symbols, and examples, drawing on the keen observations and manners of his native language.

"Existence is not a puzzle to be solved," Wiman says. Typically, storytellers, meaning *every* artist before and since Jesus spent time on our planet, don't want to explain the meaning of their art. Imagine asking a playwright after the opening night performance of a new work, "I really enjoyed the play but... will you tell me what it all means?"

Jesus must have felt the same way. In the written records of his ministry, he generally "explained" his parables only when someone in the audience specifically asked, "What does this story mean?" With his typical patience, he agreed to every storyteller's dreaded role— having to explain the meaning of what they just heard. On those occasions he patiently parsed point by point the meaning of his stories.

Reflect

How do I react when someone asks me to "explain the meaning" of my book, song, painting, poem, etc.?

Do I patiently respond?
Do I cut the person off with, "If you didn't get it the first time, explaining it won't help" or some other, more polite version of that response?

DAY 13

CELEBRATE YOUR ART

"Art washes away from the soul the dust of everyday life." — Pablo Picasso

Today, celebrate your own gifts as an artist. Whatever your genre, be it poetry, musical composition, playing an instrument, singing, writing plays, or acting, or a visual art form, yours is the gift of seeing in the dark. So, do something good for yourself today:

• Tell your Creator-Spirit how much you enjoy... cherish even... your freely given artistic gifts.

• Tell yourself you are good at what you do as an artist.... Go ahead, say it... *aloud*. I – Am – Good – At – My – Art!

•.Tell your social media contacts how much pleasure you derive from exercising your creative gift(s). No need to brag, just an honest expression of your gratitude and awe.

Don't feel guilty about spending blocks of time perfecting your gift and creating the life-giving output your gifts crave. At the same time, don't abandon your family. Take pleasure in your life obligations and responsibilities—family time, friends, other artists, work,

sleep, and fun. This isn't easy. It may take you some time to find that delicate balance.

Reflect

How hard is it for me to say out loud, "I'm good at my art(s)?"

How easy or hard is it for me to admit that my talent is a gift bestowed on me from on high, and not something I did or earned on my own?

If I have difficulty admitting and sharing my talent in public, what steps will I take to change that into something positive?

DAY 14

PERFORMANCE FRIGHT

"Frankie Presto had stage fright. ...Did you know that? It's true. He said it stemmed from his childhood, some performance he did here in Spain where the audience booed him. He never got over it. He had to kneel down and take deep breaths before every show. A lot of great ones suffer that way. Streisand. Adele. David Bowie. Carly Simon. They sweat. They vomit. But as soon as Frankie Presto got onstage, you never saw nerves." — Mitch Albom, *The Magic Strings of Frankie Presto* (a novel)

According to the National Institute of Mental Health, performance anxiety impacts about three quarters of the population. It happens to a school child singled out to answer a question or solve a problem in class. And it's a common trauma for adults who venture into a public arena, which means the majority of a population. Among

artists of every genre, performance dis-ease can torment both beginners and accomplished stars. Performance anxiety can happen to anyone performing in front of crowds. Many professional athletes, actors, and musicians report instances of feeling insecure or anxious prior to a performance. They admit to suffering terror up to the second they go on stage or stand up to speak.

Psychologist Julie Nagel says, "Stage fright is like having an accident on slippery ice. People think that if they prepare enough it can't happen. But deep down they know it can."

In addition to those cited by Mitch Albom, the list of artists admitting to stage fright includes some of the most famous stars and celebrities on the planet. Superstar tenor Andrea Bocelli admitted to interviewer Connie Chung, "I think I don't want to use drugs or medicine. The only way is to go on stage and hope."

After panicking during a 1967 performance in Central Park, New York, Barbra Streisand avoided live per-formances for decades. She admitted, "I couldn't come out of it. ...Forgetting the words shocked me. So, I didn't sing and charge people for twenty-seven years because of that night... I was like, 'God, I don't know. What if I forget the words again?'"

Reflect

What is my own experience of stage fright or,
more generically, performance anxiety?

What techniques do I use before a public appearance
to overcome anxiety and prepare myself to face my
audience?

Day 15

Qualifying as a Creative Artist

"In much of the world today, an artist is considered to be a person with the talent and the skills to conceptualize and make creative works…. Through-out history and across cultures, there are different titles for those who make and build. An artisan or craftsperson, for example, may produce decorative or utilitarian arts, such as quilts or baskets. Often, an artisan or craftsperson is a skilled worker but not the inventor of the original idea or form." — Found online at Libre Texts

The question of creative initiation may not make much sense to modern artists. Why split creativity hairs over the words, creator-initiator and artisan? If you are potter and use the gifts of the earth as your raw material, your artistry produces objects of great beauty and value to those who enjoy your creations. So dictionary differences seem to have little meaning in the real world of art. Don't painters, singers, actors and other artists draw on the

gifts of their own bodies to produce their art. Further, today's artists build on the works of predecessors in their field of talent. Recording artists often need music written by others to provide their glorious repertoire.

Reflect

Do I consider myself an artist or an artisan?

If I make a distinction between the two... why?

Day 16

Getting Started on a Project

"We tend to think that getting traction on our most important work requires that we be skilled and proficient at that work—but that's not quite right. The real thing we need to be skilled and proficient in is moving through the moment <u>before</u> the work. Once we make the shift, then doing the work itself, consistently and over time, will make us proficient at the work. Which means that the skill we really need to develop—and it is a skill—is transitioning."
— Peter Bregman, in the *Harvard Business Review*

For many artists, the hardest part of taking on a new venture is... inertia. Do I really want to start this project that may take a year or more to finish? This decisive moment is a point of transitioning from an idea that is floating around in your head and just needs you to

develop it. But that's when all the reasons not to embark on that project flood your brain.

In *Big Magic*, Elizabeth Gilbert's self-revealing book on the arts, she sees ideas as floating around the universe looking for artists to give them concrete life. She makes the point that an idea won't stick around forever waiting for you to make up your mind. She demonstrates this by admitting she had a really good idea about a book project but let other priorities supersede. That idea left her and went looking elsewhere. Some years later she learned about another author's book and... yes, it was exactly the story she had let go of earlier!

Reflect

What do I think of Gilbert's theory of creativity and ideas?

If I disagree with her, what do I believe about the origin of my own creative ideas?

Day 17

Night Language in the Hebrew Scriptures

"The hand of Yahweh was upon me. I looked: a windstorm came from the north bringing a great cloud. A fiery light inside it lit up all around it, while at the center there was something like a glowing metal. In the center were what appeared to be four creatures with the same form.... The surrounding light was like a rainbow in the clouds after a day of rain. The vision was the likeness of Yahweh's glory."
— The first chapter of the Book of the Prophet Ezekiel, verses 2-28, a biblical example of night language as our primary access to our invisible divinity

Notice the use of similes ("like," "was like" and "likeness") in the above passage. Being human you cannot physically see Creator-Spirit's full reality. All you have is a trail of breadcrumbs to guide you along your path. Following those crumbs will bring you close to

supernatural reality—at least, as close as anyone can get in this life.

The ancient Hebrews understood spiritual reality better perhaps than "moderns." They more easily grasped the meaning of night language. Even a casual reading of their image-filled texts reveals the sweeping extent of their understanding of life. The above quote from Ezekiel flows with image-filled night language.

This question arises for you as an artist. Where do you find the "breadcrumbs" that lead you to the invisible-but-real source of your art? You have your own unique answer, unique in the sense that the answer can only come from your inner life as an artist. We call some children prodigies, because they seem to have "fallen from the womb" with the ability to sing, paint, or play a musical instrument... what we call a penchant for the arts.

Childhood discovery of talent and the desire to share it may or may not fit your life story. You may be one of those—probably the majority—who stumble upon their talent somewhere in their teens... or even later. No matter. The seed of your creative gift came into existence with your birth.

Reflect

What is my dominant creative gift? How do I best express it?

When did I first discover my desire to develop my raw talent?
What steps have I taken in my life to develop my Creator-given gifts?

*How has Creator-Spirit guided and shaped my life
in positive ways... allowing me to develop and express
my talent?*

DAY 18

THE WORLD NEEDS YOUR ART

"Art gives us meaning and helps us understand our world. Scientific studies have proven that art appreciation improves our quality of life and makes us feel good. When we create art, we elevate our mood, we improve our ability to problem solve, and open our minds to new ideas. According to Dr. Shelley Carson, art's ability to improve our mood broadens our attention and allows us to see further possible solutions to creative problems.'
— Samantha Kaplan, artist

Yes, it's true. The world needs gifted artists like you. Why? Many people across the earth need outside help to see and make sense of their world. Your art emanates power and opens others' eyes through yours. That's why you and your creations enhance the betterment of society. As an artist, you read the "signs of the times" long before anyone else catches on. Your night language gifts

shine a light on truths beyond the reach of those who spend most of their waking hours treading the muddy, day language trenches of everyday life.

You are essential to the well-being of society. Where others see only darkness around and ahead of them, you have the power to light their day in small but important ways. You help them find beauty… where before there was none.

Reflect

When was the last time I looked in the mirror and saw myself as a gift to the

world, with an essential role to play in adding beauty to people's lives?

Was it today? Yesterday? Last week? Can't remember when…?

Why not begin today with gratitude for gifts I received at birth? It costs nothing and repays copiously.

Day 19

Seeing in the Dark

"Painting, for me, is something of a mystical endeavor. As an artist, I approach my canvases each morning without an agenda. Any plans I may have had before beginning are usually quickly overruled by whatever the paint has in mind. On a good day, I step aside and allow each painting to evolve as it will. I offer up my skills and talents to the universe each day and try to gracefully accept whatever the universe gives me in return."
— Rob Davenport, artist

Rob Davenport's reflective admission serves as an invitation to explore the intimate relationship between you, the artist, and your Creator-Spirit. Life entrusted you from birth with the ability to see and share something most others cannot see or comprehend. But they must see it and revel in it if they hope to find meaning, wholeness, and true love during their time on planet Earth.

Christian Wiman writes in *My Bright Abyss:* "I believe in visionary feeling and experience and in the capacity of art to realize those things. I also believe that visionary art is a higher achievement than art that merely concerns itself with the world that is right in front of us."

J. Robert Oppenheimer, lead scientist in the construction of the atomic bomb, and his team in Los Alamos, New Mexico, did something new and amazing. But on the scale of value to the human race... your artistic gifts and output serve the world in far better ways.

Reflect

How does my art surpass in value and necessity that of the inventor of the atomic bomb?

How truthfully can I say the words, "I believe in visionary feeling and experience? And in the capacity of art to realize those things"?

If the above words do not roll off my tongue without my second-guessing or thinking myself a fraud, what do I need to do to see my life and calling as an artist in a more positive light?

DAY 20

SHOVELING SAND

"I'm writing a draft and reminding myself that I'm simply shoveling sand into a box so that later I can build castles." — Shannon Hale, young adult fantasy writer

In setting out on this journey of reflection and engagement in the arts (in any of creativity's expressions), let's begin with Shannon Hale's insightful words. Both fine and graphic artists—and artists in all other genres—set out with a blank canvas, page, or musical pages eager to receive flats and sharps. In the early stages of a work you are simply "shoveling sand." Don't be surprised or frustrated when, within each draft or iteration of your work, you hear your self-editing voice tease or cry out, "There's another, better way you can do this." It's all a necessary part of the creative process.

How apt and wise is Shannon Hale's understanding of the artistic endeavor. Imagine Rembrandt wrestling with "Return of the Prodigal Son." He must have experienced moments of indecision, "Should I add another dab here or

use a slightly different pigment there?" Thirty years earlier he drew a black and white sketch of the same scene in St. Luke's gospel (15: 11-32). What else can that be than a great master's way of *shoveling sand*.

Or Giuseppe Verdi standing backstage, listening to an aria from his opera "La Traviata," and pondering, "Maybe I should have written this aria somewhat differently... better?" Does an author exist who, opening a newly published work, doesn't find something that could have been phrased differently with greater effect?

Let Shannon Hale's insight sustain you through the darker periods of your creative journey.

Reflect

Where do I place myself along the creative continuum of "shoveling sand into a box"?

In what ways does my self-critical judge hold me back instead of propelling me forward in my work?
My career?

Day 21

The Realm of Your Gifts

"The desire to create is one of the deepest yearnings of the human soul." — Dieter F. Uchtdorf, German aviator, airline executive, and Latter Day Saints leader

Whatever the nature of your artistic gifts, you:
• bring into being (create from nothing what never existed before)...
• objects *you* and you alone had to make (because no one else in the world could do it in exactly the same way).

Using your artistic gift and particular talent (*charisma*, in Greek), you give life to a world you *wish* you had received at birth... but didn't. Why? Because that raw material has waited for you—and you *alone*—to produce it with your own unique gifts.

Irish poet and politician William Butler Yeats put the concept of ongoing creation this way: "The world is full of magic things, patiently waiting for our senses to grow sharper."

Reflect

What have I created that no one else in the whole world could bring into being?

What new idea, concept, work of art nags at my spirit begging its time to enter our world?

What prevents me from giving birth to my next project?

DAY 22

CREATIVE PARTNERS

"If my hand slacked, I should rob God—since he is the fullest good…. But he could not make Antonio Stradivari's violins without Antonio…." — Antonio Stradivari

He was right. God could not make Stradivarius violins without Antonio. That craftsman received gifts that no other violin maker possessed.

As an artist—especially if you have not *yet* achieved fame and acclaim—you may be tempted to downplay your gifts. Consider another aspect of your creative talent. As the maestro violin maker pointed out, no one else possesses your Creator-Spirit bestowed gifts, no matter how common they may seem to you.

If you have the gift of writing, whether fiction, nonfiction, poetry, or journalism, no one has your identical passion and gift. Only you can produce your output. If, for example, you write for publication, countless other books may stand out as bigger sellers and

receive more acclaim than yours, resulting in more lucrative royalties, including movie/miniseries deals. So what if the vast body of the reading public has yet to discover your work—and may *never* discover it?

Like Antonio Stradivari, you and your work are unique in the whole universe. No one else on earth can create the books, write the songs, put to musical notes and voice the identical compositions you compose. Your relationship with Creator-Spirit stands unique, unlike any other artist's. Whether or not you achieve financial recognition can depend on a host of circumstances, some not within your power to control. For some fortunate artists, being in the right place at the right time makes all the difference.

Every person in the arts has a singular connection with the source of all creation. That's what matters. If there were an artists' "hell" (which I doubt), those who take full credit for their creative gifts populate its dark precincts.

Every artistic gift and endeavor forms a one-of-a-kind partnership between the Giver of the gift and you, the human partner in that gift.

Reflect

What is my one-of-a-kind gift?

How do I show my gratitude and respect for that gift?

Day 23

Your Call to Create

"Everybody needs beauty as well as bread, places to play in and pray in, where nature may heal and give strength to body and soul."
— John Muir, *The Yosemite*

"Everybody needs beauty." That means letting each person find and enjoy what is beautiful to them. Who cares if others call what they see and hear "anathema" or "garbage."

Recognizing and accepting your unique talent initiates you into a divine-human partnership. Your mission? To bring something beautiful into existence. Beauty... what a slippery word when applied to the body of human artistic endeavors. One person's beauty seems dreary to another. To a locked-in rock-and-roll fan, having to attend an operatic performance or concert recital might feel like a night—or year—spent in jail.

Similarly, an artist gifted with an operatic voice might reject rock and rap music as disgusting. That person

might even deny these genres' right to exist under the banner of great art.

Rebecca Cullen, musician and writer, puts it this way in her *stereostickman.com* article, "Music & Art: The Mind & The Muse—Making Sense of Life": "That creative muse we chased and chased and chased. We were never meant to chase him. We were meant to teach him how to breathe. We were meant to give him a voice of his own. And what he gives to us in return is indestructible creative freedom, which feeds off of our struggles and our pain, draws it all away from us, and explains it all with impossibly abstract clarity."

Reflect

Which genre(s) of the arts do I dismiss as unworthy of the name, "art"?

What personal "struggles and pain" feed my art?

How have those struggles allowed me to grow as an artist... and feed the output of my art?

DAY 24

THE MOTHER OF ART

"United with reason, imagination is the mother of all art and the source of all its beauty."
— Francisco de Goya (1746-1828), master painter

Fully conscious artists recognize that their gift comes to them from another source. Where, then, does your unique talent come from? Who "fathered/mothered" it into existence? Goya answers, "Imagination."

At the human level, imagination plays the role of mother to your ability to create. But what exactly is imagination? Consider it, as Goya did, the wild and risky faculty for which no limits exist in the search for beauty and truth.

The parenting role in art has its source in your innate ability to think and plan ahead. Without that motherlike tempering hand of reality-based reasoning and discernment, you risk living an unbalanced life. That

imbalance can result in failure to achieve your goals... or worse, failure to derive the inner satisfaction you deserve as an artist.

Imagination. What a gift! It allows you to participate in Creator-Spirit's life-giving work and offers a broad canvas on which to sketch what is in your heart. We hear so much about the "suffering artist." The Giver of your talent wants you to experience lifelong joy, not life-sapping suffering.

Reflect

What is my unique contribution to the universe of art?

In what sense am I conscious of welcoming the wild and risky faculty for which no limits exist in the search for truth and beauty?

If I haven't yet experienced and welcomed that "wild and risky" side of my art, what holds me back?

Why does that naysaying voice have so much power over my efforts to create amazing art?

DAY 25

IMAGINATION IN ACTION

"Everything you can imagine is real."
— Pablo Picasso

What would your life be like without your freedom and your ability to imagine? This imagination faculty allows you to consider your options, dream your dreams, envision scenarios of an unknown future, and find truth through the nonphysical instinct of your innermost spirit.

Every character an author creates or a painter gives image to... in fact, *any* process that transfers internal images to a physical surface or sound must already exist in a parallel universe... unseen but sensed by the artist.

Whatever your genre, you generate life in these your "children." And, like you, they will never cease to exist! Who among the vast community of authors, poets, playwrights, screenwriters, or creators of fictional characters has not felt that in their bones? But what universe do they inhabit?

You may discover an answer someday—or you may have to keep that question alive throughout your creative

life here on planet Earth. Creator-Spirit, the great sower, plants seeds in every society on earth. Artists like you possess the unique gift of nurturing one of those seeds and raising community spirits beyond the narrow boundaries of day language.

Reflect

Many children grow up hearing the old adage, "An idle mind is the devil's workshop."
How does giving my imagination free flight differ from idleness of mind?

When I let myself daydream about my career in the arts, what do I envision?

If my next thought wants to pull me down from that vision, how do I deal with it?

DAY 26

THE ESSENCE OF IMAGINATION

"Catholics live in an enchanted world... of statues and holy water, stained glass... saints and religious medals, rosary beads and holy pictures.... Catholics see the Holy lurking in creation.... We find our houses and world haunted by a sense that the objects, events, and persons of daily life are revelations." — Father Andrew Greeley (d. 2013), *The Catholic Imagination*

Creator-Spirit gifted every human being with the ability to imagine. In his book, Andrew Greely described the essential nature of this faculty. He addressed Catholics directly but by extension included everyone who believes in "sacramental" faith.

The generic word, sacrament, implies the presence of a material reality that stands for or hints at another underlying immaterial reality that gives new meaning to what is physically seen. Sadly, artists today live in a world mostly devoid of the ability to look at a material object

and "see' an immaterial presence. What results from that blindness? A widespread, mind-dulling loneliness... even hopelessness. No one should blame another for crying out, "Someone tell me, please, there's *more* to life than this!"

Reflect

Within my own faith system—or some other life-giving system—where do I find examples of "sacrament"?

If I am not an adherent to any established faith system, where do I experience a "presence within the presence" of what I see and touch?

How important is this experience to my own art?

How do I express that "other presence" in my art?

DAY 27

THERE'S MORE...

"Compassionate people are geniuses in the art of living, more necessary to the dignity, security, and joy of humanity than the discoverers of knowledge." — Albert Einstein

The arts in all forms fill the void of imaginative poverty. They do this by showering our planet with wonder and hope. What message do you, the artist, bring to your audiences? It's this... "There's more." There's more than what people see and feel and touch. ...More than the sum of human anxieties and fears.

As an artist, your vocation in life empowers you to communicate this "more" message to a fractured world. So many of our fellow humans have lost hope in goodness... lost hope in beauty... lost hope of a future. And in many cases lost hope of all meaning in life. The world needs artists like you. You have discovered within yourself a new way to speak and express the truth and purpose of our existence.

In your work, that "new way" conveys *compassion* (suffering with) and hope of more and better in life both here and hereafter... through the night language spoken and expressed in your work.

As a compassionate artist your creations serve your audiences as positive, life-affirming companions to accompany people over the course of their life journeys, be it for a moment of inspiration or longer. How? By implanting within your audiences a sense of lasting hope. You invite your audiences to share your vision of life and find within that vision a reason for renewed hope.

Without your ability to show compassion for the plight of your fellow journeyers, people's imaginations may veer off track.

Reflect

What signs of compassion do I see in the way I live my everyday life?

In what ways do I see myself as a "genius in the art of living"?

If my list is short, where can I begin today to live up to Albert Einstein's definition?

DAY 28

EXAMPLES OF NIGHT LANGUAGE

"You fill up my senses like a night in the forest...."
— John Denver, singer and songwriter

John Denver mastered the art of lyrical metaphor. In "Annie's Song," written as a tribute to his wife, he played on the music world's heartstrings with a quintet of similes you might recognize.

The object of Denver's love fills up his senses, like "a night in a forest"... like a "mountain in springtime"... like "a walk in the rain"... like a storm sweeping across a desert... like the comforting sight and sound of "a sleepy blue ocean."

What wonderful examples of lyrical "night language"!

Reflect

If I were to write my own version of Denver's song with a specially loved person in mind, what would I write after each of my five "likes"?

How did it feel to create that lyric about that someone special in my life?
What did I find most difficult? And most easy?

DAY 29

THE MIRACLE OF STORY

"[Jesus] uses metaphors because something essential about the nature of reality—its mercurial solidity, its mathematical mystery and sacred plainness—is disclosed within them." — Christian Wiman, *My Bright Abyss*

Storytelling.... Every artist plies this art form regardless of literary or musical genre. Those in the arts dive deeply into the world of story. Every nonlyrical expression of art has an artist-driven title that hints at an underlying story... an underlying truth that cries out to be heard. Take for example Rachmaninoff's lovely and haunting *"Vocalise."* Not a word is spoken, even when sung. Its haunting musical expression allows listeners to add their own story to the composer's evocative melody.

Why is that statement true? Because story provides the only medium capable of expressing a vision only the composer sees... and communicates. The universal medium of story allows you to share with anyone who

will pause long enough to listen to your music... read your writing... see your film... or observe your work of art.

Christians and non-Christians alike regard Jesus of Nazareth as a master storyteller. Some call him the greatest raconteur ever. In the contemporary language of the Catholic Pastoral Bible, Jesus opens more than fifty of his short stories (parables) with: "Can you imagine?" or its variation, "This story throws light on...."

Even John Denver's imaginative and soulful lyrics in *Annie's Song* ("You fill up my senses like a....") pale by comparison to the storytelling prowess of Jesus of Nazareth. Having awakened his listeners' inner senses, the master storyteller proceeded to share some inkling of the kind of Creator-Spirit we have. He used imaginative earth images. "Our God is *like* a (woman... king... father of two sons... farmer... pearl of great price... merchant, etc.), who...."

Why did Jesus use earthy similes and metaphors when witnessing to the nature of the invisible Creator-Spirit? Why not open the heavens and let people see God with their own eyes? Wouldn't that have made it easier for them to accept his message?

The mechanics of physical sight require the presence of an external object the brain can process into three-dimensional images. Your imagination has no such limits because of its greater capacity for "interior sight" than that of your physical eyes.

Reflect

How do I use my artistic gift(s) to help my audience "see" a broader truth than what they can take in with their physical sight?

What might I learn from Jesus of Nazareth's skill at turning words into a brightly lit highway leading to non-physical truths?

DAY 30

COME, JOURNEY WITH ME...

"Artists are people who make art. Art is not a gene or a specific talent... Art is the unique work of a human being, work that touches another.... Art is who we are and what we do and what we need. Art isn't a result; it's a journey. The challenge of our time is to find a journey worthy of your heart and your soul."
— Seth Godin, *The Icarus Deception*

Playwrights, screenwriters, novelists and song-writers... anyone gifted with artistic skills and desires... poets perhaps most of all... offer the following invitation to their audiences: "Come along with me on a journey. Free your imagination. I will take you somewhere your inmost spirit has never gone. In the end, you'll see and understand the physical world around you and the spirit-world within you more clearly than ever."

Music, story, and images in all genres of the arts draw you into deeper connection with the amazing truth of your life. Whether as the artist or the audience, art

pierces the armor of your ego and defense mechanisms. Art exposes you to the reality of your very self—ever so briefly, sadly all *too* briefly in most cases. Some exposures to art will leave indelible impressions on your psyche.

Unless you fight it, art forces you into the fourth of the Twelve Steps of recovery enshrined in Alcoholics Anonymous' invitation to self-knowledge—make a searching and fearless moral inventory of yourself... your life.

Reflect

How has my artistic gift required (forced) me to "make a searching and fearless" self-inventory?

What did I discover that might not have been clear prior to my self-inventory?

Day 31

Meeting the Enemy

"We have met the enemy and they are *ours*."
— Commodore Oliver Hazard Perry

On September 10, 1813, America's naval fleet defeated a British squadron on Lake Erie. In celebration of his victory Perry proclaimed victory. The late cartoonist Walt Kelly, creator of "Pogo," gave Perry's epic quote a new twist on a poster he drew for Earth Day, April 22, 1970. He altered the wording a bit to fit the moment: "We have met the enemy, and he is *us*." Unfortunately, Kelly's more personal, inward-looking version has outlasted that of the great naval hero.

Another way of putting this is to admit that we are at times our own worst enemy. A good resolution would be to give my all, and nothing less when I am actively engaged in the preparation stage and when performing, no matter the place or size of the venue.

Reflect

Walt Kelly spoke volumes in his little twist on Commodore Perry's triumphant victory chant. *In what ways might I be my own worst enemy as an artist?*

Day 32

The Source of Our Gifts

"Logic will get you from A to Z. Imagination will get you everywhere." — Albert Einstein

With this simple statement, Einstein reminds us that all art is conceived in the womb of imagination. True artists recognize that they cannot take credit as the source of their inspirations. They receive their gifts from another benevolent source.

Like a great sower, Creator-Spirit showers the earth with talent, gifting diverse people of every race, color and creed equally with artistic gifts and special talents. By applying these gifts within their communities, local artists soar beyond the material limitations of their "day language" existence.

The sacred writings and music of all religions express themselves primarily in "night language." Why? Only "night language" plunges you into the depths of life's two deepest mysteries: your own human nature (your "self") and the nature of Creator-Spirit (God-self).

In *My Bright Abyss: Meditation of a Modern Believer*, Professor Christian Wiman writes: "People who think poetry has no power have a limited conception of what power means.... This is why poetry is so powerful and so integral to any unified spiritual life: it preserves both aspects of spiritual experience, because to name is to praise and lose in one instant. So many ways of saying God."

A problem with "night language" is that, too often, readers... viewers... and listeners just don't get it. They may look at a work of fine art and see only paint on canvas or another foundational medium. They listen to a song and hear only sound and words. They read a novel or poem and fail to grasp either in whole or in part the author's story-within-the story or the penetrating but out of view truth concealed between the lines.

The same can be said for contemporary and classical music, whether from the hills of Kentucky or Milan's La Scala Opera House.

Reflect

What poem have I read that had a powerful impact on my life? How and why?

What book, movie, concert, theatrical production had the same effect on my life? How and why?

DAY 33

DREAMING

"Dreams are the seedlings of realities."
— James Allen, poet and philosopher

Imagination merits the title, "mother of art." Along the spectrum of imaginations, you experience the phenomena of both *night* dreams and *day*dreams. Engaging in your artistic craft requires you to recall and honor both your night dreams and daydreams... and learn how to interpret them.

Humans tend to look upon daydreams with suspicion. Parents and teachers discourage lapses into daydreaming—sometimes for good reason. Your lapses may cause you to miss important, real-world happenings like a red light at an intersection.

During sleep, creativity roams free, back and forth between the material and spiritual universes in which you daily function. During sleep, Creator-Spirit has total access to your unguarded consciousness. Both day and night dreams feed your keen and active creative spirit.

Reflect

How active is my night-dream life? Do I remember my dreams, any of them?
Or do they disappear upon my awakening?

When did a night dream find its way into my artistic expression?

What general themes seem to recur in my daydreams?

How seriously do I take my daydreams?

DAY 34

WE ALL DREAM

"Everybody dreams. Whether we recall what we dream, whether we dream in color, whether we dream every night or just every so often.... Then there's the really big question: What do our dreams actually mean?" — Rebecca Joy Stanborough, MFA, writing on Healthline.com

Dreams. Many people claim not to dream... or not to remember their dreams when they have them, except on rare occasions. What do dreams mean? You may have already asked yourself that question. What do those fleeting, slippery images and stories mean?

As an artist whose work draws its meaning from "night language," you cannot afford to dismiss this vital flow of spiritual energy and inspiration. If you give no value to your night dreams, your art will surely suffer from that loss. Sadly, you may never know the full extent

to which this "missing link" impacts the breadth and insight of your creativity.

In a dream state, you may receive the gift of the great American novel, film, play, work of art, or whatever creative gift Creator-Spirit bestowed upon you at the moment of conception in your mother's womb. As a result, you may miss the opportunity of a lifetime.

Reflect

What is my personal understanding about the phenomena we call "dreams" and "dreaming"?

How has a dream found its way into my art form?

How did that dream-story play out in my creative hands?

DAY 35

NIGHT LANGUAGE AND ME

"In our dreams we have night experiences different from our day experiences. We fly, turn into other creatures, walk through walls. We do all kinds of bizarre things. In fact, if we could do during the day what we do most nights in our dreams, we would be having 'supernatural' or 'miraculous' experiences every day."
— Rev. Michael Dowd, during an interview with Barbara Stahura, author, Certified Journal Facilitator, and Transition Writing Specialist

Your most creative ideas come available to you in the early hours of the morning. Those pre-dawn stirrings of wakefulness offer the most accessible moments of openness to your nonmaterial, creative playground. In that brief moment of time, the veil dividing spirit from matter appears paper thin.

Keeping a pen and notepad (or art journal) at your bedside provides a handy way of salvaging at least some of your creative "leakage." Lack of preparedness puts you at greater risk of losing a fleeting dream's message... forever.

My own most notable example of this occurred a number of years ago. I awakened with a story that cried out for written expression. On the spot, I had the arc of the story. The main characters made themselves known to me as a gift that arrived on the proverbial "silver platter." The following journal entry from that morning chronicles my notes written in the first moments after waking up: "Just got an idea for a novel, *Train to Bruges*. It tells the story of a young Belgian nun and an American priest who spend a weekend touring Bruges and Antwerp in Belgium."

Over the following days, I gleaned further details also in those half-awake, half-asleep moments. I made sure to record them in my journal, amplifying my previous notes. It took me a year to fill in all the blanks, draft after grinding draft. The result? My sixth novel, *The Saint of Florenville: A Love Story*, which *almost* sold to a big-screen producer... but that's *another* story.

Reflect

How seriously do I take my dreams, seeing them as fonts of creative opportunity?

When did one of my dreams lead to creative expression within my art form?

What was the dream? How did I give "flesh" to that dream in my at?

DAY 36

BRINGING DREAMS TO LIFE

"The creation continues incessantly through the media of man. But man does not create... he discovers. Those who look to the laws of nature for support for their new works collaborate with the creator. Copiers do not collaborate. Because of this, originality consists in returning to the origin."
— Antoni Gaudí, architect

In the late 1800s, a young, unproven Catalonian architect, craved the contract to design and build the newly announced basilica of *La Sagrada Familia* (The Holy Family) in Barcelona, Spain. Advisors to the Archbishop argued against commissioning Antoni Gaudi for the mammoth project. What comprised the chief arguments behind their advice?

"Gaudi's too young."

"He lacks experience to take on such a costly undertaking."

During the search for the right man. (Among the noteworthy women architects of the late 19th and early

20th centuries none seem to have worked in Spain.) One night, Cardinal Archbishop Juan José Omella of Barcelona had a dream in which a "voice" told him that God had chosen Antoni Gaudi for the task of designing and building the basilica. This highlights the importance and the sometimes surprising and lasting value of being in touch with your dreams.

We cannot retell here the whole fascinating story behind the design and prolonged 120-year construction of the magnificent Basilica of La Sagrada Familia (now open but still unfinished). That history includes Gaudi's tragic death—being hit by a tram while walking—and long delays caused by World Wars I and II and Spain's own bloody Civil War. Fortunately, Gaudi left behind plans and a miniature model of the work he had begun.

Reflect

How seriously do I take my dreams?
Nonsense?
Or springboard to creative action?

When did I feel misjudged for an artistic task that I knew
I could successfully bring to completion.
How did it feel to be snubbed?

How have I proved my worth since that dark day?

DAY 37

DAY DREAMING

"The child is the first artist. Out of the material around him he creates a world of his own. The prototypes of the forms which he devises exist in life, but it is the thing which he makes that interests him, not its original in nature. His play is his expression."
— Carleton Eldredge Noyes, art critic and author of *The Gate of Appreciation: Studies in the Relation of Art to Life* (1907)

Every artist dreams.

Your dreams and visions impel you forward in your career. In your particular art form, you tell the story of those visions that appear both at night and during the day. In doing so, you share with Creator-Spirit a partnership in creation. But of what? A future that does not yet exist... works that await creation in your mind and through your body. Creative people experience this process as "seeing in the dark."

Few writers begin a novel without imagining publication and a top-ten position on the *New York Times* book page... or your regional newspaper's... best-seller list.

Be it a school play or local theater production, every young thespian, singer, musician, and dancer onstage imagines the impossible dream of a career on Broadway or making it big in Hollywood or the great concert halls of the world.

Without these daydreams and *honored* night dreams, you will never reach the full potential of your gifts. So, keep your dream alive! You never know what Creator-Spirit has in store for you tomorrow, next month, next year....

Pablo Picasso wrote, "Every child is an artist. The problem is how to remain an artist once we grow up."

The saddest words of a gifted man or woman are, "I once had a dream, but then everything was the same as it had always been."

In the 1954 film, "On the Waterfront," boxer turned dockworker Terry Malloy (played by Marlon Brando) lamented: "I could'a been a contender. I could'a been somebody, instead of a bum!"

Carleton Eldredge Noyes also said too many children lose their artistic instinct as they grow older. As he puts it, "Imagination surrenders to the intellect; emotion gives place to knowledge." How sad....

In his book, *The Restless Heart*, Fr. Ronald Rolheiser shared a legend that captured the essence of "night language": "It is said that, before being born, each soul is kissed by God. Then it goes through life always remembering in some way that original kiss. The soul measures every experience in relation to that original sweetness.... To be in touch with your heart is to be in

touch with this primordial kiss, both its preciousness and its meaning."

As an artist, you do well to ask yourself, "Have I searched for and cherished the source of my own primordial kiss?" Or do I dismiss it as an unattainable fantasy?

Reflect

How do I personally connect with Rolheiser's "primordial kiss" concept?

If this concept is new to me, how might it make sense for me to dive deeper into that virgin lake within me?

DAY 38

JUGGLING ART AND THE NEED TO EARN A LIVING

"Woke up and went to the beach this morn. Message to all of us Creatives out there. Just CREATE! Love! Feel! Enjoy! Like I enjoyed my walk with all that God has created! Love you, my artist friends and family! Just... BE!" — Natasha Middleton, filmmaker and Artistic Director of Pacific Ballet Dance Theatre, Burbank, California

Artists aptly describe themselves as "night-language people living in a day-language world." Focus for a moment on several distinct yet complementary areas of divine expectation for you as you engage in the arts. Creator-Spirit expects you to discover, acknowledge, and hone your craft. Why you? Who knows the mind of Creator-Spirit? Your gifts come to you freely, without merit. Your vocation is to accept your talent with joy and fully live out your preordained mission in life.

How might you describe your mission as an artist... today? Your vocation and gift beg you to *peer* into the

myriad mysteries of life surrounding you. Then, *fulfill* that calling by expressing what you have seen, heard, and touched. And *embrace* that expression with all the joy and blessedness that comes from that wonderful gift of imaginative sight.

At all times, your mission calls you to humble acceptance of the truth that your talent arrived in your possession at birth as unique to you, a pure gift from Creator-Spirit.

Reflect

Have I truly embraced my undeserved gift of art? And given thanks for it?

What creative role do I play in this imagination-starved world?

How would anyone around me know that I rejoice in my talent and am eager to share it?

DAY 39

CREATOR-SPIRIT'S GIANT GAMBLE

"The man who had received one bag of gold went off, dug a hole in the ground and hid his master's money.... 'I was afraid and went out and hid your gold in the ground. See, here is what belongs to you.'

"His master replied, 'You wicked, lazy servant! So you knew that I harvest where I have not sown and gather where I have not scattered seed? You should have put my money on deposit with the bankers so that, when I returned, I would have received it back with interest.'" — The Gospel of Matthew (25: 14-30)

In bestowing artistic gifts on you, Creator-Spirit took a great risk by gifting you with the freedom to make your own vocational decisions as you journey through life. What risk? That you might not develop and share your gift to the full extent of your giftedness and leave your talent uncultivated, or worse... abandoned.

In Jesus' parable about the king and his stewards, the monarch put portions of his money into the hands of several different men. He expected these trusted employees to invest his money and earn a profit. The stewards agreed and each received a portion of the master's fortune.

While other beneficiaries "went gangbusters," investing the master's money wisely and earning a tidy gain for their king, one of the stewards got cold feet. What if his investments failed to yield a profit? Surely the king would punish him. To protect himself from failure, he hid the king's money in a safe place.

Fast forward to the present... and your artistic gifts. Creator-Spirit bestowed your creativity freely and without reserve. You did nothing to deserve your gifts. That doesn't mean those gifts came to you with no strings attached.

Like the king in Jesus' parable, your Creator-Spirit expects you to cultivate the talents you received at conception and use them in ways great or small to make the world a better place for everyone.

That often misunderstood virtue we label *humility* plays a key role in the discovery and assessment of your gifts. Humility means *admitting the truth about yourself*, including an assessment of your gifts and acknowledgment of their divine source. You live in humility by recognizing your gifts with gratitude and vowing not to let your talent go undeveloped. In this you fulfill your calling by living your personal and professional life in open and unflagging fidelity to the gifts bestowed on you.

Reflect

In what forms do I express my gratitude for the gift(s) bestowed on me at the first moment of my existence?

What have I done with my talent that I will proudly express when I meet Creator-Spirit in person?

DAY 40

PASSIONATE COMMITMENT

Believe in your heart that you're meant to live a life full of passion, purpose, magic and miracles.
— Roy T. Bennett, *The Light in the Heart*

Creator-Spirit expects you to commit yourself to *passionate* expression of your freely endowed gifts. You know or have heard of talented people who lack a passion for their craft. Or for one reason or another have stunted their personal growth, their careers, and therefore their service to the universe.

Don't withhold your gifts like the timid, play-it-safe steward in Jesus' story about someone who hid his master's money in the ground instead of investing it and earning a profit. And don't measure your success in dollars, Euros, or any other currency. Instead, measure your success by two standards: your level of dedication to your Spirit-given craft... and your willingness to share the gifts and talents you have received.

Reflect

How generous am I about sharing my artistic gifts with others, no matter the situation or the profitability?

If I lack the passion to be "out there" with my talent, what obstacle(s) prevent me from freely and generously sharing my gifts?

Do those obstacles lie within me or did someone block my way?

What resolution will I make today to nullify these obstacles?

DAY 41

A CAREER IN THE ARTS

"There is no must in art because art is free."
— Wassily Kandinsky, Russian painter and
art theorist

A career in the arts has little to do with fame or anonymity. Not all artists need to pursue a public career. Creator-Spirit expects you to view the exercise of your gift as the road to reaping the treasure of self-discovery and meaning.

Your art may go no further than the walls of your own home or writing your memoir to be read only by family and close friends. Or decorating your living space. Or spinning pottery no one outside your home will use and enjoy... or buy. You can write beautiful, heart-stirring poetry solely for the members of your household and inner circle of family and friends. All of these and other private works express your artistic gifts in a positive way.

The key to artistic fulfillment lies not in the venue of your display but in your grateful response to an inner awareness and expression of your gift. You may hear the

call to share what you have created outside your inner circle. As a vocalist or musician, you may draw satisfaction from performing in a church choir or a small local theater company.

As an artistically endowed person, you will achieve your best results when applying your Spirit-given gifts to fill in piece by piece the wonderful jigsaw puzzle of your life. At some point, you may discover within yourself a desire to explore your giftedness on a grander stage that opens before you and shows itself within your reach. Or you might not. It's your decision.

Reflect

Which of the above career choices (private, semi-private, public) comes closest to describing me as an artist?

To what extent am I following and fulfilling my divine calling to hone and share my art, whether privately or in public?

What more might I do?

What holds me back?
Time... lack of focus... fear?
If not one of those, then what...?

DAY 42

IS UNFINISHED ART REALLY ART?

"Unfinished paintings are more admired than the finished because the artist's actual thoughts are left visible." — Pliny the Younger, author and sole eyewitness reporter of the destruction of Pompei in 79 AD/CE

Composer Franz Shubert bore a lifelong reputation for absent-mindedness. He left his magnificent and appropriately titled "Unfinished Symphony No 8 in B Minor"... *unfinished*. No one knows why for sure but theories abound.

The composer often worked on more than one orchestral piece at a time. In this case, he may have felt no need to complete the composition; or he decided to leave the work in its incomplete stage and move on to something else—an intruder?—that demanded the composer's attention and energy.

Unlike the much-deserved fame of Shubert's unfinished symphony, most people, including artists, do

not consider half-completed poems, songs, films, or manuscripts "works of art" (unless they come to light post-mortem like Ernest Hemingway's *Garden of Eden*).

In the process of writing a baseball novel, I had the rare—for me—experience of working on two different novels at the same time. One story featured a major league ballplayer named Jack Thorne. In the other manuscript, I struggled to novelize Victor Hugo's catalyst character in *Les Misérables*, Bishop Charles Francois Myriel, Bishop of the off-path Diocese of Digne, in southeastern France. In each case, around the middle of the story, I hit the proverbial wall. Stuck, I saw no way forward for either plot.

Then... I experienced a felicitous (divine?) intrusion into my writing process! What if I introduced Jack and Bishop Myriel to each other just to see what might happen? I arranged that "meeting"... and guess what? They hit it off right away, resulting in *There's More: A Novella of Life and Afterlife*.

Reflect

What unfinished songs, manuscripts, or works of art have I abandoned?

How would I describe the process that caused me to give up on these endeavors?

If I found a way around my dilemma, what was it? How did it turn out?

DAY 43

TRUTH IN ART

"Art can amplify the sacred and challenge the status quo. The arts help us to hear above the cacophony and pause in the midst of our multitasking. The arts engage a sacred frequency perforated with pauses. Artists learned that there were things too full for human tongues, too alive for articulation."
— Barbara Holmes, activist, scholar, and spiritual teacher

The truth of art accomplishes what Barbara Holmes describes as the mystical power of art to "amplify the sacred and challenge the status quo." That tall order lays open the primary purpose of your craft. When you experience even a single ray of inspiration, use it to shine a light on some aspect of the mystery of the universe.

In the process, your mission in the world becomes clearer... and sometimes your burden. What mission? To call attention to at least one aspect of the great mysteries

of life. In broad terms, you play an important role in the awakening of a routine-numbed world. You fulfil your mission as an artist by probing the human psyche and spirit, including your own, and by healing wounds.

You are Creator-Spirit's chosen messenger. Your calling? To "speak" that message through your art. Your primary task as an artist? To cry out to anyone who will listen, "There's more."

Yes, there's definitely more to our truth-starved, hearing-impaired world.

Reflect

What message do I want to send out to the world through my art?

How might discovery of my vocation as an artist-messenger change the way I apply my art?

DAY 44

CREATIVITY CAN BE HAZARDOUS

"An artist experiences agony as the project develops, as the costs mount. Creation requires sacrifice. And when it is finished, it is embraced by a few but misunderstood and rejected by many."
— Christ (*pronounced Kr-ist*) John Otto, author of *An Army Arising: Why Artists are on the Frontline of the Next Move of God*

You've heard the saying, "No pain, no gain." That's life...always complex... at times quite perplexing. This comes as no great revelation as you strive daily to give expression to your artistic gift. Each and every day you experience the pain-gain complexity in the cultivation of your talent. At times, you may even become aware of a love-hate relationship with your personal creative endowment(s).

Where and how do you find the inner strength to plod forward... one day after another, when nothing seems to go right. When words refuse to fall into place. When the

music in your head balks at translation to the desired score or to your instrument. Upon approaching a blank canvas or page, your mental images may refuse to conform to your grander vision.

Art demands sacrifice. In many cases, that sacrifice takes shape in your willingness to "keep on keeping on," trusting the work worthy of your perseverance, worth the struggle, worth your sweat and blood, the mental stress.

Choreographer and film producer Natasha Middleton exquisitely expressed this struggle in her international award-winning short film, "Dissension Within." It opens with a ballerina wearing a black tutu. A war of opposites rages within her as she struggles to dance. Then the scene switches to the same ballerina on stage in a white tutu, regaled with applause and roses by an appreciative audience. Which of the two represents the real woman? Or does each version represent the same woman's struggle to find inner harmony of body and spirit? Thus, the film's title.

You can justly claim the title, "successful" artist, by measuring success in terms of the joy and satisfaction you gain from your craft... from knowing you give it the best of your skill, time, and effort.

If financial gain and a measure of acclaim follow... thank your Creator-Spirit first; then congratulate yourself for the hours, days, and years of hard work that combined to reward you with acclaim and gain.

Reflect

What is my self-image as an artist? (Put it in writing and keep it in a special place.)

*What agony have I suffered in learning and mastering
my art form?
Has it been worth it?
If it has, then in what specific ways?*

In what ways am I my own worst enemy as an artist?

Day 45

Tolerance for Frustration

"Imperfect people are all God has ever had to work with. That must be terribly frustrating.... But [God] deals with it. So should we!"
— Jeffrey Roy Holland, past President of Brigham Young University

Like every other serious artist, you need to accept that a degree of frustration will accompany your gift of artistic talent. What causes that frustration? Any number of unwanted circumstances. Not performing to your known ability... putting out great effort and knowing you "landed" your performance only to receive lukewarm response and recognition... or realizing that your best effort has fallen behind the curve of what others now see as the "latest hot new thing."

When you allow this kind of self-pity and blame to grow unchecked, you open the door to prolonged and unnecessary periods of discouragement. You may even consider "chucking" everything you worked so hard to

build and perfect. "Who did I think I was, believing I had a real gift when, clearly, I didn't?" Who says so? Generic... "people."

An artist's despair can burrow so deep that a smoldering temptation grows inside telling you to trash your "failed" canvases... shred those "failed" manuscripts... consign your innocent musical instrument to the hell of a dark closet.

Allowing this kind of thinking to set in opens the door to a career-ending mistake. Did Creator-Spirit play a cruel trick by allowing you to build your art on unrealistic beliefs and dreams?

Reflect

When did I ever consider abandoning my "so-called" gift? What triggered that negative feeling? What happened next?

What consolation do I draw from Jeffrey Roy Holland's assertion that imperfection permeates the human race... including every artist, famed and failed alike?

DAY 46

ART... A DANGEROUS WORK

"Every creative endeavor is risky. Making the invisible visible is dangerous work. Every act of creativity is an act of Incarnation."
— Christ John Otto, *An Army Arising*

As a gifted artist, you need to cherish your talent regardless of others' failure to accept what you offer. Your gift is real. Trust its validity and value. Then find your best place of expression.

What are the odds of making a living from your art? If you are an author, composer, songwriter, playwright... you need to face the fact that every year over a million similar new works compete with yours for attention and "shelf space." That number will grow as independent marketing competes with standard professional opportunities and outlets (agents, managers, editors, publishers, etc.).

In this author's 40-plus years of publication, my early books found commercial publishers and did moderately well, though far from making me either rich or famous. As

I've... "aged"... I continue writing the kind of books I personally take pride in. I no longer rely on the standard process that includes tight draft deadlines, publisher-demanded changes.... Well, let me just admit that, as my relentless life clock ticks on, the publishing world with its protracted timelines has left me in the dust.

Worldly success or not, I've kept writing. Why? Because there always seems to be another book nagging at my brain, begging me to give it a go... bring it to life... send it out into the world to find readers who—in admittedly smaller numbers—might enjoy what pours from my soul. Then that nagging piece finds its way to a completed manuscript... and then to a book I can hold in my hands and offer to the world as my gift in response to Creator-Spirit's prompts.

So, never give up. As long as creative prompts come to you—and you alone, begging to see the light of day, just... do it! No other human being living now or still to be born can do it for you in exactly the same way. Your gift is unique, unmatched by any other artist, and bestowed upon you... and no one else in the whole wide world.

Reflect

What does Otto mean when he says, "Every act of creativity is an act
of 'Incarnation'" (becoming flesh and blood)?

What risk do I take in starting a new creative project?

What do I consider my greatest fear? How do I keep from yielding to that fear?

What holds me back from starting my next creative project?

What's the worst thing that can happen if I fail?

But what if I don't fail?
What then comes next?

DAY 47

WHAT CREATOR-SPIRIT EXPECTS

To quote Christian Wiman again, *"Art is often better at theology than theology is."*

As a working artist you do well to discover, acknowledge, and understand the source of your creative gifts. They do not come entirely from *your own* initiative and talent. Nor do they exist for your *exclusive* benefit.

So acknowledge your art as a personal and unique gift bestowed on you by Creator-Spirit to share with your inner communities and more broadly the whole world, now possible through electronic media sources.

Some artists' work may cross national and cultural boundaries. For others, that "world" might not reach beyond the limits of family, civic, social, professional, and religious communities. No matter. Your calling is the same... to help others gain deeper insight into the meaning of their lives.

You might think—and prefer—this topic to fall under the heading, "religion." Fortunately, art and your creative

gifts go far beyond what most religious people might think of as a strict need to "explain" the divine or—as someone put it—to "unscrew the inscrutable."

Reflect

What does Wiman mean by "Art is often better at theology than theology is."

How often and in what ways do I acknowledge Creator-Spirit as the source of my artistic talent?

Day 48

Art and Truth

"Art is not a study of positive reality; it is the seeking for ideal truth." — John Ruskin, leading art critic of the nineteenth century

Insightful? Yes. But here's the problem.... After 2,000 years, Pontius Pilate's cynical question for Jesus of Nazareth, recorded in John's gospel (18: 38) still hangs over the human race, particularly in the United States of America... *"What is truth?"*

Prehistoric cave dwellers became the first writers on the planet, chiseling indelible indentations on stone. Humankind's earliest graphic artists designed images and embellished them with bright colors using primitive paints and brushes. They did this to keep pictorial records of "modern life" as they lived it.

Today your artistic gifts call you, along with creative people in every genre, to apply your skills to seeking, parsing, and mining that sacred five-letter word, T-R-U-T-H.

Inside of you lies the sinical Pontius Pilate and a host of other nags snarling, "What *is* truth?" Take charge and send them away from the door to your heart.

Reflect

What does that malleable word "truth" mean to me?

How do I express my unique impression of truth through my art, as I live and interpret it every day?

Most important, how can I know that my art—whatever my genre—speaks the truth of human life and the universe, as I see and understand it?

DAY 49

WHAT IS TRUTH?

Pope Francis explained, "The experience of beauty is an important and even primary factor in our search for meaning and happiness, and the experience liberates and transfigures our lives. From this emerges the important and necessary task of artists, particularly those who are believers, and allow themselves to be enlightened by the beauty of the gospel of Christ. ...To create works of art that bring us, in the language of beauty, a sign, a spark of hope and trust where people seem to give in to indifference and ugliness."
— From a 2016 article by Hannah Brockhaus, senior Rome correspondent for Catholic News Agency.

Pope Francis conveyed his understanding of the following universal aspects of artistic expression:

• Experiencing beauty in your own life serves as an essential element of meaning and happiness in all persons' lives.

• Allowing yourself to find an essential component of your life in biblical and other writings of the past that still speak to and influence the quality of your gifted life.

• Gifting those who live in earthbound despair and hopelessness with a call to awaken dormant hearts and souls by offering a lifeline of hope and trust through what you paint, write, compose, dance, sing, play....

• Learning and speaking the language of truth, giving it expression through your works.

• Committing yourself to the solitary labor of perfecting your art, thereby enabling audiences to receive art's universal truths.

Your vocation—your divine calling—invites you to play a key role in changing our world for the better.

Reflect

How would I describe the "truth" of my art?

When I engage in my individual field(s) within the broad spectrum of the arts, what do I want my viewers/ listeners/participants to feel in that moment?

What do I want them to take away with them afterwards?

DAY 50

CREATIVE IDEAS

"A creative idea begins with a germ of an idea. It grows within us, then begins to burst forth. Every artist comes to a point where they are not happy unless they finish the project they started."
— We hear again from *An Army Rising* by Christ John Otto,

Do you have an unfinished symphony lying around as Franz Shubert did, or another musical composition relegated to the depths of cyberspace? Or do you have half a manuscript, canvas, or statue gathering dust? If you do, it's time to ask, "Why does that piece remain in limbo?"

Did you run out of inspiration? Or did you take a leap beyond your skill and capacity to bring the piece to satisfactory completion? Or you've declared a work unworthy of more precious time and energy. Why? Do you fear exposing your work to a public that might reject it or worse... yawn, turn away, and declare your

"masterpiece" unworthy of anyone's time... money... or both?

Be aware that you produce works unlike anything that ever existed. You do this by applying unique gifts endowed by Creator-Spirit. A true artist believes that somewhere in the world an audience awaits discovery of your work. You just need to keep "doing your thing" searching for your audience.

But "there's the rub." The fun part of being an artist derives from creation of the work itself. You may also identify as one of those rare artists who enjoys the challenge of marketing as much as creating the work. More typically, you have less enthusiasm for the marketing end of your business. Or you are one of the majority of artists who have little time and less interest in taking off your creator's cap and playing the role of salesperson. Or you just don't have the money to launch a full blown marketing campaign.

The truth is that most successful artists put equal energy into marketing, getting out there personally, yes even "hawking" their wares.

Reflect

What percentage of my time do I spend promoting my work... and myself? What marketing techniques have proved most successful for me?

Which of my unfinished works or discarded ideas cries out for a second chance to join my completed works?

What germ of an idea nags at me for attention and life?

DAY 51

DO YOUR CREATIONS SPEAK THE TRUTH?

"We all know that Art is not truth. Art is a lie that makes us realize truth, at least the truth that is given us to understand. The artist must know the manner whereby to convince others of the truthfulness of his lies." — Pablo Picasso

In Andrew Lloyd Webber's musical rendition of *Phantom of the Opera*, the Phantom implores his student, Christine Daaé, to "listen to the music of the night."

As an artist, you received the gift of listening to and speaking the language (music) of the night. Fiction writers, composers, musicians, actors, singers—performers of all types and genres—speak the language of deeper, often nonverbal truths of existence. Sharing your gift offers our mostly day language world an open door through which to discover the "secret garden" of their souls.

Reflect

How aware am I that, whatever my place in the arts, I tell lies that speak a deeper truth?

How does that awareness feel when I admit it... and share my truthful "lies" with the world?

DAY 52

A QUESTION

"You use a glass mirror to see your face; you use works of art to see your soul."
— George Bernard Shaw

Does your art contain and communicate the personal truth of your soul? For example, in all the arts people wonder: "Is that incident based on the artist's personal life experience?" Or "Is the main character based on your life?" Almost always the answer to both questions is "no... but...."

Every artist reveals facets of his or her own life experiences and values... but often in deep disguise. Those who know you personally and have shared major events with you, those twists and turns in the artist's life, may recognize pieces and parts of your personal story. But artists scatter those seeds widely across a range of subjects and characters—including the villains. In fact, no two renderings of the same model or scenic wonder come forth as identical.

A hundred coloratura sopranos may bring to life the role of Mimi in Giacomo Puccini's wonderful dramatic opera, *La Boheme*. No two of them will sing and portray the consumptive young woman in exactly the same way. Each brings her own unique voice and spirit to the love-struck Mimi as she dies, tragically leaving Rodolpho, her weeping lover, a total basket case (though still in excellent voice).

Reflect

Taking a moment to ponder on how my art contains and communicates my own personal truth, what do I come up with?
Any surprises?

How aware have I been that works of art—in any genre— reveal something about the originator of the piece?

How does a singer, actor, or any artist bringing to life the work of another (composer, playwright, actor, screenwriter, poet, etc.) reveal his or her unique self in that rendition?

How do I rise to this challenge?

DAY 53

MUST YOU BE WORTHY OF YOUR GIFT?

God, the giver of all gifts has only imperfect people to work with. That must be terribly frustrating.... But [God] deals with it. So should we! — Jeffrey Roy Holland, past President of Brigham Young University

Holland responds to the "worthiness" concept with a wise reality check about your own fitness to possess your artistic gifts. The simple truth? No one has the right to stake a claim to "worthiness" when it comes to their talent. Consider your artistic talent as completely undeserved. The history of art testifies that Creator-Spirit bestows talents and skills without a litmus test for personal merit and moral worthiness. This doesn't mean talent comes to you with no strings attached.

Therefore, never hold your gift in the arts as your own doing. Neither can you claim that you create something from nothing all on your own. Always hold your talent as an unearned and undeserved gift from Creator-Spirit.

So don't waste valuable time wondering who in your family tree to credit with your artistic gift. Although creative parents may have an edge for recognizing the signs of a child's creative instinct, gifted parents do not automatically produce children with talents identical to theirs. To paraphrase Holland, "Deal with it... the way the giver of all gifts does."

Reflect

To what extent can I claim my talent as inherited from my parents or someone else down among the branches of my family tree?

What is my usual way of responding to compliments about my work?

How has this reflection shifted my attitude towards my artistic output?

DAY 54

THE GUILT OF GIFTEDNESS

"One of the recurring themes I find in ministry with creative people is the pervasive guilt they feel for not having a 'real job.' There seems to be a deep belief that creative work is not really work. Because of this belief, many artists choose to find jobs that do not use their gifts in order to 'fit in.'" — Christ John Otto, *Bezalel: Redeeming a Renegade Creation*

Guilt about your giftedness? Yes, it can sneak up on you. Some talented people just can't or won't see themselves as possessing a genuine gift whose expression makes the world a better place to live in... for everyone. In doing so, they diminish the talent Creator-Spirit has given them and leave their talent less than fully developed... no matter how famous they become. In the process, artists deprive the world of the benefit of their endowed talent and destiny.

Reflect

How have I experienced the kind of gift-guilt described by Christ John Otto?

What can I do about gift-guilt when it sneaks in to sabotage my joy?
What <u>will</u> I do?

Day 55

Forgive Yourself

"It's forgiveness that makes us what we are. Without forgiveness, our species would've annihilated itself in endless retributions. With-out forgiveness, there would be no history. Without that hope, there would be no art, for every work of art is in some way an act of forgiveness. Without that dream, there would be no love, for every act of love is in some way a promise to forgive. We live on because we can love, and we love because we can forgive."
—Gregory David Roberts, *Shantaram*.

It's hard to imagine, but some artistically gifted people wrestle with lifelong feelings of unworthiness for a gift that makes them stand out above so-called "normal" people.

Countless stories chronicle the terrors of well-known people in all realms of the arts. Some solo performers suffer panic attacks that nearly paralyze them before

going onstage or appearing in a public setting with a spotlight that focuses entirely on them. But when they do step out... something magical happens. They transform into their artist persona as soon as the crowd's applause greets them.

Dwelling on an unforgiving, negative mindset poses a dangerous threat of spoiling your career and robbing you of the self-satisfaction and joy you deserve. By some mysterious inner algorithm, you are in danger of detouring into a downward spiral. Creator-Spirit gives artistic gifts for your happiness and benefit, not to make you suffer. Drinking, taking drugs, nitpicking your faults do not go hand-in-hand with talent. Just the opposite. You possess in-born gifts intended to bring joy to your life and to your audiences. Go forward with your head held high, acknowledging and generously sharing your gifts. Let yourself enjoy the deep interior satisfaction Creator-Spirit wishes for you. You don't have to become a major star of stage and screen to live your gifts to their fullest. Many highly gifted individuals have almost no public persona and little recognition beyond the boundaries of their chosen environment. Instead, they find "backstage" ways to find personal satisfaction and fulfillment in pursuing other equally important creative lifegoals. You may find yours in a church choir or a local theatre company... or by teaching drama or literature to eager students with their own artistic goals.

So... let go. Make art.

Enjoy the ride, no matter how bumpy, and live life with a grateful heart.

Believe in your value to an often beauty- and joy-starved world.

Reflect

How have I found reconciliation in living my art within other life-choices I consider equally important?

How difficult or easy has it been for me to accept my limitations and still pursue excellence in my chosen field?

How has this reflection on interior self-forgiveness changed my inner thinking and decision making?

DAY 56

DEALING WITH DIS-EASE

"God grant me the serenity to accept the things I cannot change; courage to change the things I can; and wisdom to know the difference.

"Living one day at a time; enjoying one moment at a time; accepting hardships as the pathway to peace; taking, as he did, this sinful world as it is, not as I would have it; trusting that he will make all things right if I surrender to his Will; that I may be reasonably happy in this life and supremely happy with him forever in the next. Amen." — Reinhold Niebuhr (1892-1971), "The Serenity Prayer"

How do you as an individual artist deal with your own foibles, character flaws, and moral wrongdoings? Neibuhr's short prayer, in an adapted form, has brought peace of mind to mega-millions plagued by harmful addictions of every type. It has also offered inner peace to

a host of Type A artists driven by out-of-reach expectations and achievement, competitiveness, and irritable impatience.

Let Niebuhr's prayer be on your lips, or at least in your heart as you go forward. Enough of the impatient, perfection-seeking artist, the guilt-ridden artist!

Reflect

What "tricks" or techniques have I learned to keep my expectations balanced and my feet on the ground?

How hard is it for me to set realistic goals for the effort I put in and the public's reception of my work?

DAY 57

NEGLECTING YOUR GIFT

"Where there is undeveloped talent, there is unfulfilled destiny."— Gina Duke, author and lecturer

If you don't hone your craft through study and practice... if you won't put in the work... how can your giftedness give flight to people's spirits and aid their desire to reach the highest level of their potential?

If you let self-doubt, introversion, or fear of failure silence your gifts, you may not lose your talent entirely. You may, however, bury that potential so deep beneath the muck of self-indulgence that you may not remember ever having those gifts or where you misplaced them along the slippery path to full human development.

The sad truth about "bottling up" your unique talent (an apt choice of words when alcohol plays a role in the theft) is that you might let down a universe in dire need of being lifted up. Creator-Spirit bestowed these gifts, not solely for your own personal enjoyment.

You need to discern carefully how Creator-Spirit expects you to offer the world (that is, *your* part of the world) all the beauty, joy, and inspiration you can during the span of your lifetime.

If you neglect your growth and practice as an artist, you may never entirely lose your divinely bestowed gifts. But you may fall short of fulfilling the purpose of your existence... to enhance others' quality of life as they take in and enjoy your offerings to the world.

Reflect

Following Gina Duke's warning, where do I stand regarding my "undeveloped" talent?

What will I do today to appreciate and enhance my artistic gift(s)?

DAY 58

WHAT IF I ABUSE MY GIFT?

"I believe each of us has a certain quantity of talents. It's up to us to do something with them. Will we share them and multiply their effect, or will we just bury them out of cowardly fear of getting out in front of people? You might be missing out just because you aren't spending your talents wisely."
— Matthew Kenslow, author of *Juggling the Issues: Living with Asperger's Syndrome*

"Abuse." What does that mean in the context of art? It speaks to a gifted person's misuse of genuine talent in favor of feeding the *dark side* of human nature. Your talent wants you to do what is best in humanity's collective spirit.

History testifies that artists who were or are less than perfect in their personal lives have produced amazing masterpieces in every area of the arts. In his 1999 biography, *Victor Hugo*, Graham Robb chronicled the life

of the famous author. In the introduction, Robb paints the picture of a man whose life manifested such complexities that *whatever* anyone might say about Hugo would be true.

The author of *Les Misérables* and *The Hunchback of Notre Dame*, fits the description of "a man of contradictions." The biographer cites those who knew Hugo as offering the following descriptors of him:

• womanizer/adulterer
• self-centered boor, uncaring about others' well-being
• angelic child prodigy
• militant monarchist
• revolutionary socialist
• defender of the downtrodden (*les misérables*)
• repressor of revolts
• instigator of riots...

and *more.*

Could Hugo—or anyone on earth—claim all those wonderful and terrible qualities all wrapped up in one human being? In his case, it seems so. You might have run across someone like that in your life. A few examples leap to mind, but it's best that this author keep their identities to himself.

Hugo's long-time wife, Adèle Foucher (d. 1868), might have had a different opinion of her genius husband. Truth be told, however, Adèle herself had no right to claim the moral high ground as a paragon of virtue. Around 1831, Adele became romantically involved with Charles Augustin Sainte-Beuve, literary critic and her husband's friend.

At the same time, Victor became enamored with an actress Juliette Drouet, who became his long-time mistress. So, many authors' literary hero merits the

descriptor, *man of contradictions*, one who lived a life of opposing forces.

This raises the contemporary question: Do drugs, alcohol abuse, adultery, and other vices *enhance* an artist's gifts... or *detract* from them? A hard question to answer. Would Ernest Hemingway and others have been better writers, musicians, composers, etc., if they had been "straight arrow" folks? We don't have a definitive answer, but the question should intrigue us.

Reflect

If I step outside myself and look at my life with some objectivity, what do I see that might not serve my art well—and may, in fact, prevent me from achieving my best work?

What am I willing to change in my life and way of being for the betterment of my own artistic talent?

Day 59

Pushing Frontiers

Artistic inspiration is sometimes an act of grace, though by no means always. — Christian Wiman, poet and editor of *Poetry Magazine*

Most artists—at all points along the scale of talent, proficiency, maturity, sobriety, and sanity—strive to push their creativity as far as their gifts, energy, and desires will take them. In the process, they risk crossing boundaries of civic, social, and religious values, both in their work and in their personal lives.

As an artist, you give so much of yourself for the entertainment, inspiration, and social education of your audiences. You put your work out there for the rest of us to scrutinize and critique. And you do so at great personal risk. You may even gain an impressive measure of financial return on your investment. Rightfully enjoy whatever measure of fame and esteem comes with success in your field. To reach that level, you put yourself at the mercy of the public and the media.

But what if... what if you abuse your innate talent, negating Creator-Spirit's desire to show compassion through your art and lift humanity to a place of mercy and respect for all people?

Creator-Spirit must have a special love for artists! Even those who engage in their art for reasons some may find distasteful, even "immoral"!

Creator-Spirit has great compassion for us writers, poets, actors, singers, musicians, painters, sculptors, et al., and must give us lots of moral leeway.

Reflect

In what sense can I look in the mirror of my life and say with conviction, "I have returned the blessing of Creator-Spirit's gift by making the world a better place for all... and by striving to make myself a better person"?

If my honest answer to the above question is, "No, the practice of my art doesn't make me a better, more wholesome and joyful person. Nor do I aim to make the world a better place for everyone to live in"....

What am I willing to do, beginning today, to turn that negative attitude around and start myself on a better road to fulfillment and internal joy?

DAY 60

A MOMENT OF TRUTH

*"It is not only what we do, but also what we
do not do, for which we are accountable."*
— Moliere (born Jean-Baptiste Poquelin)

When your life is over, Creator-Spirit will say to you,
"Come now, show me what you've done with the talent I
gave you... that moment when I kissed you and sent you
into the world to fill it with your art and thereby make
your world a better place for your contemporaries and
for generations to come."

Reflect

Each of us must have a ready answer to these all-
important questions:
*What do I have to show for the artistic gifts I've
been given?*

In what ways might I be squandering my gifts or not using them to the full extent of my ability?

DAY 61

THE SILENCE OF YOUR ART

"Suddenly it was terribly quiet, as if the earth itself were too stunned to breathe. I know this sound; silence is part of music. But just because something is silent doesn't mean you aren't hearing it."
— Mitch Albom, *The Magic Strings of Frankie Presto*

Mitch Albom's best-selling novel should be a "must read" for you—and for every artist—in the genre of your gift. *Frankie Presto* pays loving homage to all who receive and respect their gift.

Like many people in our "rush to do" society, you may find silence uncomfortable. Especially, if you live—as most artists do—amid a bustling society that places primary value on high-volume output and public performance. At times, you may feel guilty about your desire for periods of inaction... seeming to do nothing useful... needing to recharge your inner batteries during periods of creative silence. Yes, a full understanding of the

creative process demands possession of that one essential ingredient.

Silence is sacred in any artistic endeavor. So much goes on in that moment of active respite. Better than other artists, musicians understand the need for silent spaces between notes. Rare is the artist who does not step back periodically before adding the next stroke. Photographers most of all spend extended time pondering a scene before rolling the camera or snapping the shot. On the stage, pauses between words let the actors say so much. Before producing any work of art, you do well first to bore deep inside yourself.

What happens within you during the silence of your artist's soul? A lot! Activity in the form of *imagination...* out of which flows *inspiration*, followed by *observation*, leading to *preparation* for the next word or musical note... *action*. Following each phase of this process, you will discover the breadth and length of your own one-of-a-kind gift. In that silent instant, you become aware of your unique status in the universe, past, present, or to come.

Michael E. DeSanctis, retired professor of fine arts at Gannon University in Erie, Pennsylvania and author of *Building from Belief: Advance, Retreat and Compromise in the Remaking of Catholic Church Architecture* (Liturgical Press), quotes French composer Claude Debussy who expressed the importance of silence for artists: "Music consists as much in the silence between the notes as it does in the sounds of the notes themselves."

Reflect

What is my attitude toward silence?
Do I think of it as non-productive, wasted time?
Or as a time to recharge my inborne creativity?

Which of my past or current creative ideas "took flesh"
during a time of rest and renewal of my inner energy?

Day 62

Inspiration... That "Epiphany" Moment

"Imagination is at the heart of everything we do. Scientific discoveries couldn't have happened without imagination. Art, music, and literature couldn't exist without imagination. And so anything that strengthens imagination, and reading certainly does that, can help us for the rest of our lives." — Lloyd Chudley Alexander, *The Stone*

Imagination conceives the possibility of a new creation. For a work to have flesh and blood, imagination needs a partner in the form of *inspiration*. Another word for inspiration is "epiphany." This sudden enlightenment offers insight and a path into the storehouse of your creative gifts. Always remain open to seminal concepts that may grow from some thought, insight, even a casual personal encounter that sparks awareness, excitement, and creative energy. Let's call it an artist's "Wow" moment. Something becomes clear that arises with you

unannounced. It changes the way you perceive something.

In an instant, your epiphany moment allows you to grab hold of your life-changing energy. Some experience this as finding the missing link in their life. By their very gift and calling, artists immerse themselves in a life of such inspired moments. If you've already experienced an epiphany, that unexpected moment when, in a flash, a missing link burst forth. An unformed concept you've imagined only in vague terms begs to take flesh under your professional care. On the wings of that inspiration, a path forward magically opens up within you, offering clarity and a desire for further development.

What happens next? A moment of exhilaration... followed by an urge to go to work, to give flesh to whatever work of art imagination and inspiration came to life within you.

Like many artists before you, you may have an unfinished canvas, book, poem, song, screenplay or stage play, or other creative work on your bookshelf or stored on your computer.

Don't fret. Not every creative idea makes it into a full-blown, presentable work. That's normal... and a great mystery. Sometime later, you may experience a flash of enlightenment. In that moment you will find yourself on the same wavelength as your Creator-Spirit. That shelved but ever present creative idea may rise up and cry out for completion.

When that moment comes... be ready!

Reflect

Artists of all types and genres are the world's primary imaginers:

"Through our imagination we are given the opportunity to be creative."
What work(s) of mine sprang suddenly from my imagination (an epiphany) into concrete existence?

What creative ideas or half-finished works have I stored away for possible future inspiration and completion? Maybe it's time to dust one of them off?

DAY 63

IMAGINATION... DIVING DEEPER

"The power of imagination and art is at the level of soul, where we do not consciously know what is happening. Therefore, we cannot engineer it, do not need to understand it, nor can we fully stop its effects!" — Franciscan Father Richard Rohr, OFM, founder of the Center for Action and Contemplation

Imagination. The Latin root word *imago* (image) reveals the process of picturing for ourselves what Creator-Spirit might be calling us to bring forth from the deep and silent well of our creative gifts.

Imagination allows us to explore the past and anticipate the future yet to exist. It plays a vital role in what we call our *mental* health. This faculty offers you an essential tool for remodeling your world... and your life in the process. Sadly, too many creative types experienced parental criticism for using their innate capacity to imagine. But some of the world's most

influential people have praised imagination as an essential human faculty. The following list names just a few of them.

Nineteenth century moralist and essayist Joseph Joubert calls imagination "the eye of the soul."

Carl Sagan said, "Imagination will often carry us to worlds that never were. But without it we go nowhere."

Harry Potter author J.K. Rowling had this to say about this essential human faculty: "Imagination is not only the uniquely human capacity to envision that which is not, and, therefore, the foundation of all invention and innovation. In its most transformative and revelatory capacity, it is the power that enables us to empathize with humans whose experiences we have never shared."

In *An Army Arising*, John Christ Otto expressed the role of imagination as "one of the most important parts of our mind. It gives us the ability to see the impossible. It helps us see the unseen. Through our imagination we are given the opportunity to be creative. This is something that reflects the personality of God more than anything else."

So cherish Creator-Spirit's gift of imagination. Develop yours to the fullest.

Reflect

Richard Rohr wisely notes that "the power of imagination and art is at the level of soul, where we do not consciously know what is happening."
When have I had the experience of a creative thought, an idea, coming to me seemingly "out of the blue"?
To what do I attribute this phenomenon?

Which of my own artistic projects do I attribute to imagination's "under the radar" gestation?

Day 64

Observation... Creative Engagement

"Observation is the action or process of observing something or someone in order to gain information."
— *Oxford online dictionary*

Like other artists, it's probable that you're a "people watcher." You observe individuals and events with a creative eye, even as they occur. You collect mannerisms and speech patterns, smiles and tears, different tones of voice and the moods that launch them. You collect and process this data in real time, then store it for review and creative use at some later time. Your observation skills inform you about objects, events, attitudes, and phenomena. Many in the arts transfer their mental notes to a journal, even a scrap of paper.

Fueled by your creative imagination, you draw on these stored images and concepts when you revive a particular incident for observation. Suddenly, you see a path forward to convert that memory into a "flesh and blood" work of art within your genre. We call this process

the "creative cycle"... or better, "creative recycling." You don't copy what you've observed but use that stored memory as a springboard to create something new of your own making.

Reflect

When and how did a stored memory find its way into one of my creative projects?

DAY 65

PREPARATION... THE RAW MATERIAL OF ART

"By failing to prepare, you are preparing to fail."
— Benjamin Franklin

Your creative process demands preparation. Compare it to a seed that needs time to take root in the soil of your creative mind and heart. This initial period requires solitary application of faculties and skills that will enable you to create a work that evolves from a tiny seed into ripe fruit picked from the branches of your imagination, inspiration, and observation.

Let's use a musical example. Before producing anything, composers become aware of music heard with the inner ear. Then they translate that initial inspiration into an array of notes in sharps and flats. Collecting the seminal elements of this material inspired artists to begin building a physical rendition of the notes and melodies heard within their internal soundboard.

Lyricists—often the composers themselves—snatch the newborn fragments of words and phrases, the gathered fruit of silent musing. Then begins the next

phase in the creative process, blending those lyrics with their own or another composer's melody.

Vocalists enter the scene. Their well-trained voices turn the notes and lyricists' words, adding their unique and varied renditions of the newborn creation.

In the arenas of theater and film, skilled actors hone the scriptwriter's words and action prompts... relying on the fruit of countless solitary hours spent memorizing lines to give unique expression to the playwright's or scriptwriter's gifted words and story. This same process applies to all artistic genres.

At every step, you consider how you might apply this scenario to your art form and current projects. Often a surprising truth emerges from a creative work. It arrives in a single word... *silence...* interior silence and external silence. To call silence emptiness misses the whole point of art. The gift of stillness eludes some artists, to their own loss. Reverence for the "dramatic pause," whether in music, on stage or screen, even in writing may be the magnet that raises performance from okay to magnificent.

There exists no other "magic way" to raise you to your peak performance. So, rather than fear or shun silence, bless the hours, days, and years of practice and study that brought you to that place of performance. What began as a tiny seed gestating in the silence of acceptance and preparation can bring your talent to full bloom.

Reflect

How comfortable am I with silence?

How has solitary preparation allowed me to succeed in my art?

What do I or might I say to a fledgling artist who wants greatness
but without a tolerance for silent preparation?

Day 66

Your Desire for Excellence

"When any master holds 'twixt chin and hand a violin of mine, he will be glad that Stradivari lived, made violins, and made them of the best.... If my hand slacked I should rob God— since he is the fullest good.... But God could not make Antonio Stradivari's violins without Antonio." — Antonio Stradivari

Just uttering the name, Antonio Stradivari, causes the creative mind to produce images and soul-stirring sounds of a violin. The master seventeenth-century violin maker's name stands for excellence in craftsmanship. The above quote reveals his partnership with the divine Creator-Spirit. Consider your desire for excellence, then, as a free gift to you from that same Creator-Spirit... a much needed gift in our technical (gadget-loving) society. Your respect for high quality work and your yearning to run with Creator-Spirit's gift already makes the world a better place for everyone.

To call this statement boastful misses the point. A simple statement of fact never comes from wrongful pride. It simply states a truth. God would not make Stradivarius violins without Antonio. He had received a gift no other craftsman could claim.

Creator-Spirit has partnered with you personally... and every other artist... offering gifts unique to each so that no two artists possess identical skills. Consider yourself in truth... one of a kind in your field of the arts.

Reflect

How might I apply this truth about my uniqueness to my artistic gifts?

Fill in the blank. *God could not make or do _____ without me.*

DAY 67

REACHING FOR THE STARS

"God created humans in God's image; in the image of God the Lord created them; male and female."
— Book of Genesis 1: 27

Creator-Spirit splashes night-language gifts like a star shower spread across the "canvas" we call the Universe. Some Christians have a generic word for this kind of universal generosity. They call it *"sacrament"*—meaning a palpable, close encounter with the personal presence of our invisible Creator-Spirit.

The 13th century Persian poet Rumi offered this insightful declaration: *"The finger that points to the moon is not the moon."* It's just a finger... but that finger plays an important directional role. It guides our vision to the object at which it points.

We tend to INFLATE our stature in the endless universe. In our search for ultimate truth, we need to distinguish between Creator-Spirit's role and the role of

our interior "pointing finger." The universe's—and our own—Creator stands as the sole originator ("author") and final destiny of all artistic gifts and works. Like you, individual artists play a service role as faithful stewards and sharers of the gifts showered on us.

Reflect

How conscious am I each day of the gifts I have received?

To whom do I credit my inborn talents?

What is my typical response when I offer my gifts to the public and receive expressions of pleasure and wonderment at my talent and performance?

How often do I internally express my gratitude to my Creator-Spirit for my artistic gifts?

DAY 68

LISTENING TO THE PROPHETS OF OLD

"Say to the Israelites, 'I am a sign for you,' for what I have done will happen to them. They will be deported, exiled." — Book of the Prophet Ezekiel (12: 1-12)

The Hebrew prophets had the thankless job of relating Yahweh's signposts in the form of visions and messages they received. They provided fellow Jews with a spiritual roadmap to help them along the journey of lifelong fidelity to their God.

In the Sixth Century BC/BCE, Yahweh God of Israel instructed the holy prophet Ezekiel to put on the "costume" of one being shipped off for exile by a conqueror (Chapter 37). In both dress and words and at his own peril, Ezekiel served as Yahweh's finger pointing at the people of Israel. He reminded them of the promises of their compassionate Yahweh. Ezekiel may have felt foolish, but he did as Yahweh instructed. While wearing this costume, the prophet showed himself to his

rebellious fellow religionists and delivered the message you read at the head of this reflection.

When you apply yourself diligently to your unique artistic trade, the works you create and/or perform fulfil the vital role of co-creating the goodness of this world we all share. Through words, movement, and film, you make the Spirit's compassionate presence and love visible in our world today.

Reflect

Where do I go to replenish my store of wisdom when creative instincts seem to be "running dry"?

How conscious am I that my personal gifts and works of art make the world a better place for everyone to live in?

If this is a new concept for me, what will I do to raise my awareness of this truth?

DAY 69

YOUR CALL TO HUMILITY

"I always say, 'Be humble but be firm.' Humility and openness are the key to success without compromising your beliefs." — George Hickenlooper, filmmaker, "The Man from Elysian Fields"

For Hickenlooper, humility means telling the truth about yourself... to yourself... and to others. Don't confuse humility with a type of personal falsehood that drives you to self-diminish your talent. An example might go like this:

Fan: *"You performed so beautifully tonight."*

You: *"Oh, it was okay, I guess. I wasn't at my best"* (when you know you "knocked it out of the park").

A truly humble response calls for a simple: *"Thank you. I'm so pleased you came."*

As you can see, true humility accepts the truth that yes, you are a *tiny* but *important* pointer to the mystery and beauty of Creator–Spirit's interaction with the human race. You serve the universe as a vital human

conduit through which Creator-Spirit connects with your audiences. *Conduit,* as used here, implies a *dynamic and intimate connection.* Why do we call a television network/station "a channel"? Because it serves as a means for passing images and data from the studio into the inner sanctum of your home.

Reflect

How do I usually respond when someone compliments me on my work or performance as an artist?

How good am I at telling the truth about myself, to myself?

DAY 70

MORE ON CHANNELING

"Make me a channel of your peace. Where there is hatred... let me bring your love. Where there is injury... your pardon, Lord... and where there's doubt... true faith in you."
— St. Francis of Assisi

Singer, poet, and mystic Francis of Assisi (1181-1226) understood this truth well. He saw his life's mission (and ours) as "channeling" Creator-Spirit's peace, love, and pardon to the world.

Channeling refers to the process of sharing your gifts through a medium within your realm of giftedness. In that process, you become a small-'c' creator, a human pointer spotlighting Creator-Spirit's love and compassion for all humanity.

On her website, *ask-angels.com*, Melanie Beckler defines channeling as: *"allowing love from the higher realms to flow through you."* Yes. As an artist, you serve as a medium channeling Creator-Spirit's desire for relationship with everyone who walks upon the earth... and those countless people destined to occupy our planet

in the future. That's why we have museums and why visual and sound recordings live on long after an artist has exited this mortal realm.

Reflect

How do I channel peace and love through my art?

When did I last have a moment of actual awareness that my art has served as a channel of goodness and life?

What was the occasion?

How did it feel to exist within that moment of conscious awareness?

Day 71

Creator-Spirit's Hidden Activity

"Be praised, my Lord, through all your creatures, especially through Brother Sun, who brings the day; and you give light through him.... Of you, Most High, he bears the likeness.

Be praised through Sister Moon and Stars... Brothers Wind and Air... Sister Water... Brother Fire... Mother-Sister Earth... those who forgive for love of you, those who endure sickness and trial...

Sister Bodily Death... praise and bless my Lord and give thanks and serve him with great humility."
— St. Francis of Assisi, "Canticle of the Sun"

Francis viewed *all* creation, both living and inanimate, as a sacrament in the classical theological sense of serving as an outward sign of Creator-Spirit's invisible presence and activity. He wasn't talking about some voodoo kind of

"channeling" but a call for you and all artists to acknowledge three key elements of gift:
• the reality of your gift's divine source
• your role in the ongoing and universe-wide creative process
• your service to others (a prime purpose of your art).

Francis also said, "Your deeds may be the only sermon some people hear today." Playing off his words, you can say without self-serving exaggeration: "My art may be the only 'sermon' someone will hear today."

Reflect

When did I last read, see, or hear something that transported me out of the details of the present moment into a higher sphere?

What was it about the work that caused my heightened (seemingly "out of body") experience?

My art may be the only "sermon" someone hears today. *When did someone give me feedback along those lines about my performance?*
How did I receive it and respond?

DAY 72

INTENTIONALITY

"When I stand before God at the end of my life, I would hope that I would not have a single bit of talent left, and could say, 'I used everything you gave me.'" — Erma Bombeck, author of *Life is a Bowl of Cherries*

My younger sister, Toni, acted and sang in a number of theater productions in and around the greater Los Angeles Area. She also did some television work. Toni had a different set of talents from her operatic sister Natalie, but that didn't stop her. She knew her gifts and enjoyed displaying them in front of a variety of audiences.

How I've wished I could sing, play the piano, act on stage, but I possessed neither the talent nor a craving in these areas. I took guitar lessons for a while but barely advanced beyond "Twinkle, Twinkle, Little Star."

In the Tenth Grade I surrendered any thought I might have possessed of becoming a publishable writer. My dream ended when my English teacher read my assigned

short story aloud to the whole class. He couldn't—or wouldn't—stop laughing as he read it. He panned my work with such mocking humor that everyone—except yours truly—about fell out of their desks laughing. I vowed on the spot never to try my hand at fiction again. How could I put myself in that vulnerable position—ever?

Not until midlife did I discover… and trust… that I did, in fact, have some talent, a modest measure of genuine giftedness. I found that I could write publishable fiction, nonfiction, and poetry. Who would have guessed?

I decided in my forties to show my Tenth Grade teacher how wrong he had been to snuff my budding talent.

Reflect

When did I experience mortifying criticism of my artistic work?
How did it spur my desire to develop my talent?

How careful am I not to douse the flame of a young, developing artist?

DAY 73

BECOMING AN INTENTIONAL ARTIST

The artist is nothing without the gift, but the gift is nothing without work. — Émile Zola (1840-1902) French novelist, journalist, and playwright

The creative process calls you to become an "intentional" artist. Intentionality demands your full awareness of *what's truly going on* when you create or perform as an artist.

I did a lot of public speaking, primarily within the context of my role as lay minister at a large suburban parish in the San Francisco Bay Area. Before each class, homily, or workshop, I spent some quiet time gathering my thoughts. I prayed: "Lord, let me speak well of you. Let my thoughts be your thoughts, my words your words."

Another way to put this is to remove the focus from *yourself* when in the process of creating or performing. *Then* what? Pay homage to the source of your talent, your Creator-Spirit. And *then* what? Acknowledge those who

helped along the way to enhance your talent. As a wisdom-led artist your primary challenge is to attain clarity about the gifts you possess... and clarity about those gifts you wish you possessed... but don't.

Let me share another personal story. I have two talented sisters. Natalie, now retired, had an amazing operatic voice. As a pure-toned and expertly trained coloratura soprano, she sang the lead role of Santuzza in the Santa Monica (CA) Opera Company's dramatic production of Pietro Mascagni's *Cavalleria Rusticana.* At the ripe old age of 13!

Over a forty-plus year career, she performed nearly every leading coloratura role in the Italian operatic repertoire. But she played no other musical instrument! She knew her gift and spent her entire career perfecting her craft.

Reflect

How do I see myself as an "intentional" artist?

How does my art reflect my ownership and practice of intentionality?

DAY 74

THE ART OF SUFFERING

"Trusting in nothing but suffering is a dangerous path. Suffering has a reputation for killing off artists.. But even when it doesn't kill them, an addiction to pain can... sometimes throw artists into such severe mental disorder that they stop working at all." — Elizabeth Gilbert, *Big Magic*

Elizabeth Gilbert exposes the big lie that the arts and, therefore artists, must suffer to produce great—or even—respectable art. She cites famous artists who made suffering the price they paid to produce marketable art: painter Francis Bacon and a host of writers... Ernest Hemmingway, Norman Mailer, and Oscar Wilde to mention only a few. A whole generation of chart-topping musicians used drugs and alcohol to "improve" their creative output. Gilbert cites these and more artists, male and female, across the horizon of singers, writers, musicians, painters... the whole gamut of artistic talent. She sets the record straight about the need to seek and

inflict suffering as a pre-condition for success and fame. She "outs" this mindset as simply sad and untrue. The moral of her story is to enjoy your art *sans* the need for self-inflicted pain.

Perfecting your craft requires hard work, perseverance, and expenditure of mental and physical energy. You don't need any "help" in the form of artificial, self-inflicted, and destructive pain and suffering.

Reflect

How convincing is Gilbert's argument against such methods?

To what extent do I believe her assessment of the negative value of self-inflicted suffering?

If I disagree with Gilbert, what "talent-enhancing" habits move me forward in my chosen field(s) of art?
Why do I use them?
Do I really need these so-called "talent enhancers"?

DAY 75

ART FOR THE SAKE OF ART

"We have taken it into our heads that to write a poem simply for the poem's sake... and to acknowledge such to have been our design would be to confess ourselves radically wanting in the true poetic dignity and force. But the simple fact is that, would we but permit ourselves to look into our own souls, we should immediately there discover that under the sun there neither exists nor can exist any work more thoroughly dignified, more supremely noble, than this very poem, this poem per se, *this poem, which is a poem and nothing more, this poem written solely for the poem's sake."*
— Théophile Gautier, poet, dramatist, novelist, journalist, and art and literary critic (1811-1872)

Théophile Gautier applied the term, *"l'art pour l'art,"* to all creative works, but he did not originate the phrase. It appeared earlier in the writings of French-Swiss

novelist and political activist Benjamin Constant (1767-1830) and in the works of French philosopher Victor Cousin (1792-1867). That hallowed concept surfaced again in the writings of American poet and short story writer Edgar Allan Poe (1809–1849).

In the 20th century, Metro-Goldwyn-Mayer Studios adopted as their motto the Latin phrase, *Ars Gratia Artis* (Art for Art's Sake). Even today on its opening logo screen—featuring a roaring lion—the studio declares art's independence from outside critical judgment and intervention. The innate truth of art provided reason enough for its existence. In the mid-Twentieth Century, movie studios had to fight ultra-conservative scrutiny and censorship. They compromised with the censors. By the late Twentieth Century, censorship had dwindled as social mores changed, especially in the Western world.

Reflect

How does my personal sense of morality temper my works of art?
Or does it?

In what sense do I consider my contributions to art as reason enough for their creation and propagation?

How would I respond to censorship of my work?

Day 76

No End to Learning

"I'm still learning as a writer. I'm still developing. I don't think I realized just how much that would happen on my journey." — Veronica Rossi, *NY Times* and *USA Today* bestselling author of "Under the Never Sky" series

Your *native* (inborn) and *gifted ability* to create and perform works of art requires elevated and unending development. Your corner of the arts, demands that you hone your craft through dedicated SPR (Study... Practice... Repetition). This means you must not declare at any point that you have maxed out your potential. How can you or any other artist know your creative tank is empty? How can you be sure you do not have another... or multiple works within you that may exceed anything you have yet produced?

When are you too old to keep going? Too ill? Or just too wearied by past rejections and failures? In answer, consider the example of theoretical physicist Stephen

Hawking (1942-2018). In 1961, at the age of 21, he received a diagnosis of motor neuron disease (a form of ALS). Undaunted, he went on to publish one major scientific book after another over four-plus decades!

Conquering inertia—fueled by a sense of failure and defeat—demands commitment to a lifetime of learning your craft by enrolling in targeted classes, workshops, critique groups, and active participation in professional organizations within your field of artistry.

As you grow more proficient in your gifted craft, you have two choices, each healthy and satisfying:

• keep your artistry private and solely for your own enjoyment... and

• seek opportunities to make the product of your effort available for others to enjoy.

You may prefer to display your talent and its expression on a smaller, more private and personal stage. Or you may follow your instincts to explore opportunities to perform on a grander stage. Follow *your* passion, not someone else's. Find opportunities to perform in shows, films, TV, and other venues offering broader exposure— and pay what you deserve. Let your passion guide you wherever desire and serendipity may lead you.

Reflect

When I let myself dream of my present and future in the arts, in what direction does my passion lead me?

How willing am I to put myself "out there" seeking opportunities to learn and perform?

How brave am I when it comes to facing and silencing my inner naysaying voice... the one telling me that my talent is wanting... and my dreams unachievable because you just aren't good enough?

DAY 77

CO-LABORING WITH CREATOR-SPIRIT

"A creative idea begins with a germ of an idea, it grows within us, and then it begins to burst forth. Every artist comes to a point where they are not happy until they finish the project they started."
— Christ John Otto, *An Army Arising*

As a gifted artist you collaborate with Creator-Spirit in bringing life, joy, beauty, and laughter into a tear-stained world. To succeed in this collaborative venture, you'll need to call upon and engage your inborn physical, mental, and spiritual strengths. Once you embark on that journey, with Creator-Spirit as your partner and guide through bright streets and dark backroads, good things will come your way. And you open the door to unexpected ventures, challenges, and opportunities beyond anything you imagined.

Reflect

What are my strengths as an artist in my field?

How hard am I willing to work to achieve my desired goals?

"Every artist comes to a point where they are not happy until they finish the project they started."
Considering my past creative works, what evidence have I seen that I am determined to apply and grow my talent to the fullest?

How do I respond to inner voices telling me I've "shot my wad" and passed the peak of my talent?

Day 78

The Arts... Both Gift and Call

"Unable to stop the madness that had ripped apart the former Yugoslavia, Vedran Smajlovic honored the memory of his friends and defied their killers by doing the only thing he was good at. Placing his chair in the middle of the street, he took out his cello and bow— musician and instrument melding into a single defiant force. Eyes closed to the surrounding destruction, he rendered the mournful 'Adagio in G minor' by Tomaso Giovanni Albinoni."
— Joan Baez, singer and political activist

What's not to love about the cello, especially in the hands of a skilled musician playing from the depths of a suffering soul? This instrument took center stage in the PBS documentary, "Joan Baez: How Sweet the Sound."

The film highlighted her 1993 visit to the war-torn and terrorized city of Sarajevo, Bosnia. She highlighted a moving encounter with Sarajevo Opera cellist Vedran

Smajlovic, who dressed in his best performance tuxedo and performed daily amid the ruins of his beloved city. This offering to his fellow Sarajevans represented the artist's supreme achievement... becoming one with the work... and one with his long-suffering audience.

Be it as a musician, actor, painter, writer, or any other performer endowed with creative gifts, you do well to strive for the kind of passion displayed by Vedran Smajlovic.

Think of Michelangelo producing his Sistine Chapel ceiling masterpiece spending hour after hour, day after day for five years, lying on his back high up on wooden scaffolds.

Consider architect Antoni Gaudi living the last years of his accident-shortened life within the dusty, grimy construction site of Barcelona's emerging Sagrada Familia Basilica (now open but as yet unfinished after more than a hundred and thirty years).

Consider Victor Hugo creating his idealized (and idolized) protagonist, Jean Valjean, in his timeless novel, *Les Misérables*.

What constitutes the greatest gift you can offer to the world? It's your generosity... not hoarding your transcendent talent and experience. As an artist, you gift differently skilled humans with an opportunity to transport themselves in spirit to a higher realm of contemplative unity—be it ever so brief. You possess wisdom and vision beyond human comprehension or verbal description. Fully conscious of your lofty and sacred calling, you make the world a better place for the rest of us.

Reflect

How deep is my passion for perfecting and sharing my art?

What goes through my mind when I perform, be it on the grandest of stages or locally and without fanfare?

Day 79

All Art is Story

"Story is the primary verbal means of bringing God's word to us. For that we can be most grateful, for story is our most accessible form of speech. Young and old love stories. Literate and illiterate alike tell and listen to stories.... The only serious rival to story in terms of accessibility and attraction is song, and there are plenty of those in the Bible too. Story doesn't just tell us something and leave it there, it invites our participation. A good storyteller gathers us into the story." — Rev. Eugene Peterson, *Eat This Book: A Conversation in the Art of Storytelling*

Storytelling probes the essence of artistic endeavor. Everyone knows about Adam and Eve in the Book of Genesis. Although not an historical account of the creation and travails of the first humans on our planet, we have much to learn from those first chapters. First, we must applaud the unknown author's gift of storytelling.

Each character has a story to tell, including Adam's, "Don't blame me, the woman made me do it."

Whether you sing, dance, act, write—whatever your artistic talents—you belong to the great caste of worldwide storytellers. The gift of art knows no racial, class, or economic conditions. All—even those who deny the ability to tell a story—receive some aspect and degree of this universal artistic gift. Imagine a world without storytellers... with no one to pass down ancestral histories, one generation to the next.

True, you cannot imagine—or would want to live in—a world devoid of story.

Reflect

How conscious am I of telling a story through my art?

What overall message(s)—stories—do I wish to communicate to my audiences when I perform?

Day 80

A Wannabe's Paralysis

"The need to be a great artist makes it hard to be an artist. The need to produce a great work of art makes it hard to produce any art at all.... Fear is what blocks an artist. The fear of not being good enough. The fear of not finishing. The fear of failure and of success. The fear of beginning at all."
— Julie Cameron, *The Artist's Way*

I've had conversations with talented people who admit to having finished one or more manuscripts, poems, song lyrics, et al. Then I ask, "Have you submitted your work for publication or published the work independently?" I'm bewildered when I find or hear of "closet" writers and musicians who confess to having shelved half- or nearly completed works. They now gather dust in a file drawer or in the cyber-dungeon of their computer.

However you choose to do it, your calling as an artist empowers you to channel Creator-Spirit's beauty, com-

passion, and love outward into your environment. Whether you have a tiny or vast audience enjoying the products of your craft doesn't matter. Your mission and challenge as a gifted artist demands that you bring *something* into being... where before there was *no*-thing.

Reflect

How many unfinished works have I stored away for some nebulous future completion and release?

What holds me back from shopping my work around to appropriate sources of publication?

What seminal idea floats around inside me right now, awaiting my creative attention and action?

DAY 81

FINDING YOUR VOICE

"Music expresses that which cannot be put into words and cannot remain silent."
— Victor Hugo, *Les Misérables*

Victor Hugo expressed this conviction in reference to composers and musicians. What a perfect depiction of every artist's dilemma... and great challenge! The gift of art, by its nature, begs you not to hoard your artistic experience and its fruits. Your ultimate gift to Creator-Spirit and the world is your "voice." You cannot... must not remain silent. If you hoard your gift, using it solely for your own gratification, you risk forfeiting the good you can do by sharing your work. With whom? Those who need your offering for their personal inspiration, entertainment, and yes... relief from a life burden, even if for a short while.

You dare not remain silent and invisible with your gifts. In the Broadway show and later film, "The Sound of Music," composer Richard Rodgers and lyricist Oscar

Hammerstein II remind you that love, the greatest art of all, begs you to "give it away."

Irish singer, songwriter, musician, and producer Enya Patricia Brennan, best known simply as Enya, echoes Hugo's, Rodgers' and lyricist Hammerstein's conviction. She offers us her rendition of composer Robert Lowry's haunting "How Can I Keep From Singing?"

> *No storm can shake my inmost calm,*
> *while to that rock I'm clinging.*
> *Since love is lord of heaven and earth,*
> *how can I keep from singing?*

Sharing your art enriches both you and society. In the words of World War II martyr and mystic Anne Frank: "No one has ever become poor by giving."

Reflect

In what way can I express that I have found my "voice" as an artist?

How generous am I at sharing my artistic gift(s)?

What more might I do to brighten the lives of others?

DAY 82

CREATOR-SPIRIT'S GIFT

"I am a humble artist molding my earthly clod, adding my labor to nature's, simply assisting God. Not that my labor is needed, yet somehow I understand, my Maker has deemed it that I too should have unmolded clay in my hand."
— Kumbel Kumbell (Piet Hein)

Danish mathematician, inventor, designer, author and poet Piet Hein (1905-1996) often wrote under the Norse pseudonym Kumbel, meaning "tombstone." His short poems first appeared in the daily newspaper *Politiken* after the German occupation of his beloved homeland in April 1940.

In the above poem, Hein expressed his conviction that your inborn talent comes as Creator-Spirit's gift to you... and through you to the world. You cannot take sole credit for your talent. It's not of your making. So by all means, take rightful pride in your abilities, but remain humble enough to credit your Maker as the source.

Justifiable pride... truthful humility. With that mind-set, you can own your gifts and find joy growing in your art.

Reflect

What does "justifiable pride" mean to me as an artist?

How do I express that pride in my art?

What holds me back from creating something wonderful out of the amorphous inspirations floating around inside me?

DAY 83

GIVING YOURSELF AND OTHERS A LIFT

"Art is a human activity having for its purpose the transmission to others of the highest and best feelings to which men [and women] have arisen." — Leo Tolstoy (1828-1910)

Our gift is given for us to lift ourselves and others beyond the routines and limitations of *"day language"* life. In plying your craft, you create wings that enable dull imaginations to lift off and soar. Your artistic gift resembles a deep interior volcano boiling within you... looking for an outlet. You have undoubtedly felt at times a pressing compulsion that seeks—*demands*—outward expression.

Created for beauty, you cannot truly live without channeling your Creator-Spirit in some positive way. Your innate and unquenchable beauty resides at the deepest level of your being. Only when sharing your gifts do you fulfill your highest purpose and mission. To quote naturalist John Muir: "Everybody needs beauty as well as

bread, places to play in and pray in, where nature may heal and give strength to body and soul."

Acclaimed spiritual writer Rev. Ronald Rolheiser, OMI (Oblate of Mary Immaculate), sees caring for the seeds of beauty as holy work: "In the depth of our souls, we carry an icon of the One who is Beautiful." In your art you carry the fire of love and keep it burning brightly to light others' path.

Reflect

How strong is my craving for beauty?

Where do I find the object of that craving?

How do I use my creative gifts, as John Muir suggests, to "heal and give strength to body and soul"?

DAY 84

MUST YOU PERFORM IN THE PUBLIC ARENA?

"My creativity gets put into my garden, which always needs attention and love. I don't mind because pruning trees and bushes is like sculpting. I enter into the aesthetic quality of the act. It is quite engaging and touches my soul in a very deep way. I seem to be able to connect with the life force in the plants and the dirt." — Carol Larkin, artist, sculptor, art teacher, gardener

After retiring from decades of creating and teaching art to high school students, Carol Larkin devoted her full creative attention to gardening. In a private conversation, she opened my eyes to the truth of her artistic post-retirement expression of her many artistic gifts.

In answer to the title question, "Must you perform in the public arena?" we answer with a resounding, "No." The following list shows the many ways to share your gifts and talents... on smaller but equally significant stages:

- teaching...
- directing a chorale or church choir...
- facilitating others' expression of their art through... agenting artists... publishing their works... directing performers on stage, screen, television and other outlets
- supporting the arts by enabling artists to share their work and gain recognition
- choreographing for dance.

Reflect

How do I relate to Carol Larkin's choice of post-retirement art forms?

What additions would I make to the above list of ancillary, art-related endeavors?

DAY 85

SPEAKING IN "TONGUES"

"We're from all over the Roman Empire. Our Hebrew isn't very good, but when these people speak, we hear them in our own mother tongues." — Acts of the Apostles 2: 11, the Pentecost experience

So, do artists speak in tongues? Do *you*? Let's see....

For the first time since Jesus' resurrection from the dead, his disciples came out of hiding and went out into the streets of Jerusalem unafraid of the consequences. They began proclaiming the good news of his "Way" to pilgrims who spoke a wide range of individual native languages. Those who listened puzzled over one remarkable phenomenon. Each understood everything the Hebrew-speaking Peter said to them... in *their own* native language. How did that happen? They didn't know.

Doesn't that describe the experience of every artist? You "speak" the language of your particular artistic gift. But as your audiences experience what you produce, each person receives and translates it according to their own personal spirit.

People who experience together the same performance or viewing do *not* experience it in exactly the *same* way. You may have heard the Latin expression: *"De gustibus non est disputandum."* Translation: "You can't argue when it comes to personal tastes." As you experience another artist's work, you filter that experience through your own temperament, spirituality, and personal philosophy of life. Thus the joy—and the risk—you take in "doing your thing" (sharing your gifts) in the public arena.

What if your book, film, or performance gets two stars from some critics rather than the five you expected... and knew you deserved? How much weight do you give to negative reviews? Like many artists, you may give negative reviewers of your work more weight than those who love your work. You respond to a downbeat voice that whispers: "Those who praise your work are just being nice." Or this version: "My negative critics are a lot smarter than the rest of my audiences."

Reflect

How do I react to negative criticism and reviews?

If I am one of the many artists who give more weight to negative reviews, what would it take for me to reconsider and challenge that reaction?

How willing am I to change my off-kilter response?

DAY 86

REMEMBER... CELEBRATE... BELIEVE

"Only the artist can see in the dark." — Rev. Brian Joyce

Do you recall that same quote from your Day 5 reflection?

You have the privilege of belonging to society's privileged and essential corps of imaginers... its worldwide band of dreamers. Creator-Spirit chose and appointed you to that role within human society. That same Creator-Spirit bestowed your artistic gifts at your conception (*or before?*) and left them to germinate and blossom over the course of your life.

What a vital service you offer to humanity! The better your work, the better our society. You lift audiences out of the routine of their often hum-drum daily existence. You have the ability to raise them to the realm of Spirit, whatever that might mean in your life and faith system.

Never lose sight of your vital role in the creative process—remembering, celebrating, never ceasing to believe in yourself and your Creator-Spirit's gift. You exist as a singular point of light among the planets and billions

of stars that same Creator-Spirit splashed across the universe.

So, don't ever forget... You are not the source of your gifts. Instead, your mission as a gifted artist calls you to channel divine blessedness through your art. And here's the best part. Your gifts will remain in the world after your spirit leaves this earth, because your contributions to the arts will live on in history and into Afterlife.

So, remember... celebrate... believe.

Reflect

Don't ever forget... you are not the source of your gifts.
How does this statement resonate within my artist's spirit? Or do I reject it?

What, then, is the source of my many gifts?
My own hard work? Inherited genetics?

What is my personal belief about life after death?

How does it feel knowing that my art and artistry will continue to inspire audiences for the rest of my life and... for centuries (like Aristotle, Leonardo DaVinci, Mozart, and others long gone from this planet)?

Day 87

Remember... Celebrate... Believe

Remembering

"Artists work to illuminate the margins and make societal changes. Rather than the word 'role,' I prefer 'commitment.' Over many years as an arts educator, I have helped people and communities find their voices and express their concerns through individual and collaborative art projects. This used to be called public art. Now, it is often known as social practice." — Ginny Sykes, artist and essayist

As an artist, do your best to remember your daydreams... and night dreams as well. Your daydreams launched you on your creative voyage into the "What if?" and "Why not?" of your existence... the work and money you've expended in honing your craft... the promises you've made—to yourself and others. Those daydreams,

however, did not launch your artistic journey. Those dreams only made you aware of the gifts you had already received at the instant of your creation.

Your calling leads you to remember what you've seen and what you've imagined. Build on your original gift by probing the outer limits of your inbred talent... what you may refer to as your personal talent.

Here's another way of putting this interior discovery. Without realizing it immediately—this awareness can rise gradually like the night-dispelling sun. As you grow in awareness and understanding, you embrace your gift without specific direction or plan. You begin by "playing" with your talent. Clarifying your talent comes gradually (unless your gift takes hold early and you merit the inscribed badge... "child prodigy").

Growth in awareness of your vocation leads you to self-awareness as the eyes, ears, and heart of society. You add to the voices of your artistic peers offering one more voice to the many that nourish society's hopes and dreams. With that vocational awareness comes the responsibility to live by Creator-Spirit's life-map, lifting the hearts and minds of society... adding beauty and light to the dark shadows of too many others' lives. You invite your audiences to discover the wholesomeness and beauty lying dormant within their individual selves.

Yes, you possess the gifts of healing and inspiring others, giving them an opportunity to set aside their troubled lives, at least in that moment. What if you don't use your gifts for the benefit of others? Well, Creator-Spirit took that risk when endowing you with a measure of divine creativity.

Reflect

What is my own experience of remembering my day and night dreams?
Do I search my soul for their meaning?
Or do I dismiss them as nonsense?

When did one of my night dreams influence my artistic works?
What was that dream?

What specific work of mine resulted in an artistic piece, whether in whole or in part?

DAY 88

REMEMBER... CELEBRATE... BELIEVE

CELEBRATING

"If you do say yes to an idea... your job becomes both simple and difficult. You have officially entered into a contract with inspiration, and you must try to see it through, all the way to its impossible-to-predict outcome. You may set the terms for this contract however you like. In contemporary Western civilization, the most common creative contract still seems to be one of suffering." — Elizabeth Gilbert, *Big Magic,* a book of wisdom gained from her writing career

As Elizabeth Gilbert says in her wise and insightful book on writers and writing, some artists mistakenly believe personal angst and internal suffering allows them to produce their best work. Others believe their best work results from a reckless plunge into a lifestyle of

narcissism, alcoholism, and drug addiction... take your pick.

It's true that some authors have produced masterpieces while in the stupor of addiction. It leaves you to wonder how much greater those works might have become without their author's addiction of choice. We'll never know.

What many artists have yet to learn—and may never learn—is the sheer, unadulterated *JOY* of "doing" art. Yes, the road to great art requires endless labor... hours and days spent alone at your writer's desk... artist's palette... dancer's barre... actor's rehearsal hall. But you also need and deserve work that brings you a sense of pure joy. Joy and heartfelt appreciation for your gift will drive you forward to each new stage of your creative journey— without destructive habits to hold you back from your best effort and best work.

Remembering ("mindfulness") makes *true* celebration not only possible but achievable. So, receive with gratitude and gladness your privileged status of co-creating with Creator-Spirit. Sharing your gifts with a world in dire need of reasons to celebrate life has the potential to bring insight and gladness to the hearts of those who receive your gift. And a generous measure of joyful celebration to you, the artist.

Reflect

How do I celebrate my own work?
My accomplishments?
Even my failures?

To what extent do I believe or reject the concept that great art can only emerge if I suffer physically, mentally, and spiritually to bring my art to life?

Where do I find pure joy in my art?

When and how did I learn to embrace joy rather than suspect it of dulling the quality of my work?

DAY 89

REMEMBER... CELEBRATE... BELIEVE

BELIEVING

"It has been said that faith is a certain widening of the imagination." — Lucy Hart, poet

As a gifted artist, what do you expect after completing a satisfying performance or other artistic expression? Applause, widespread acclaim, a prestigious award? Okay, but what else? As a fully aware artist in your field, let your highest expectation be that your art elevated the hearts and minds of your audiences, in both tangible and spiritual ways. That you helped the members of your audience see beyond the external, physical sight of your performance.

Take some time every day to inhale... wonder at the divine source of your gifts... and express your gratitude. Creator-Spirit encourages your imperfect self to beautify and elevate hearts and minds.

The joy in this kind of celebration makes you want to...

REMEMBER with clarity of mind and heart the source of your gifts...

CELEBRATE with enthusiasm your undeserved gifts and rejoice in the joy and enlightenment they inspire in your audiences...

BELIEVE in yourself and your undeserved gifts with a growing appreciation and enthusiasm.

Let this endless "remembering-celebrating-believing" loop nourish your talent throughout your career... and to the end of your life in this world... and into the next.

Reflect

With how much faith and enthusiasm do I remember... celebrate... and believe in the reality of my artistic gifts?

What inner conflict prevents me from celebrating and believing in my gifts?

How resolved am I to dismiss negative thinking that tries to hold me back?

What helpful techniques have I found that help me to keep my focus on celebrating my achievements?

DAY 90

CAN I CHANGE MY MIND?

"So often in life we are told that we do not measure up, that we aren't good enough. We even tell ourselves that we will never succeed. Our days are filled with worries, cares, and concerns. We feel overwhelmed. But science and Scripture say otherwise.

We are not designed to go through life with a 'fearful spirit,' not able to cope with or face our problems. We are wired for love: every cell in our body is created to respond to thoughts and feelings of life, wholeness, passion, and truth....

"We can face whatever life throws our way because we stand on firm ground. Our experiences will never be perfect, but when we choose to pursue a life of love, victory will always be possible."

— Neuroscientist Dr. Caroline Leaf, PhD, *Switch On Your Brain: The Key to Peak Happiness, Thinking, and Health*

One of the biggest mistakes you can make as an artist is what I call poverty of will. You allow yourself to doubt your ability to pay the human price of creating the works that beg for release through your one-of-a-kind creative mind. So, you shift that doubt to blaming God, the Universe, your own mind and physicality for not taking hold of a sudden inspiration that arrived seemingly 'out of the blue.' Like so many of your fellow artists, you must fight any doubt that tries to creep in and take hold of you the moment you lay eyes on a blank page or an empty screen on your monitor.

"Where will the words come from?" wonders the writer or lyricist.

"What if I can't hold onto the music I heard upon awaking from a fleeting dream?"

"What a great first line came to me... but where will the several hundred pages that follow come from?"

"The next nanosecond may be the most important of your life! Will it be, "I can't?" or will it be, "Okay, let's give it a try" and just start putting words or notes on a page. Every artist must live in a spirit of self-trust. "Sure, I might fail. But so what? Better that than not trying."

"Before writing a single word of my 2020 novel, *Inspector Javert: at the Gates of Hell,* the first line came to me. 'Where am I?" Victor Hugo's despised policeman finds himself alone... not a sound to be heard, no light by which to see, no awareness of being in his fit and prized body. Only darkness. Solitude. With that one line as a prompt, I led Javert on the journey to reconstruct his life...

and death—how he got to that shadowy state of wonder, "Where am I?"

Reflect

What is my own "Where am I?" story of finding myself staring at a blank page, screen, canvas, sheet of music?

What happened next? Did I accept the challenge? Pass on it?
Why did I make that choice?

How did my decision thrust me forward as an artist...
or hold me back?

DAY 91

STRIVING FOR BETTER

"When we strive to become better than we are, everything around us becomes better, too." — Paulo Coelho, *The Alchemist*

As an artist, ever striving for and reaching another plateau of success becomes your greatest life challenge. Whatever happens next, you can proudly say, "I gave it the best I had." You have only partial control of whatever might come of the work you release into the universe.

You may have just put the last brushstroke on a painting or breathed "Amen" after writing, The End, to conclude a written work. Or you may have just composed/performed the "perfect song" in your repertoire and rightly say, "This is my best work... to date." What you think and say next can change your career... your life. Take a deep breath, step back and say aloud, "That was really good. What shall I do next?"

You belong to an amazing community of life en-hancers... doing your small part to make the world a better place through sharing your gifts. Paulo Coelho

challenges you to see a greater truth than just the value of your newly completed work... to see in it more than just yourself but what you brought to life.

You may know of someone who, standing in the deepening shadows of life, started working on another book, song, painting, theatrical play, or television show. These elder artists understand that they owe it to the universe and everyone in our world to create just one more piece of art... share one more product of their inborn talent.

Why do these artist keep creating? The world needs them to give flesh to their gleanings from the universe of ideas and inspirations... and convert their newly acquired insight into the common language of their era and art form.

On Day 16, you reflected on what Elizabeth Gilbert says in her nonfiction book, *Big Magic*, if one artist doesn't snatch and tame that idea when it passes through them from the universe, another artist... living sometime... somewhere in the world... will harness that ephemeral concept and give it life. What the heavens create, she says, will travel the universe to find another artist in whom to plant your rejected call to create something good and necessary to the collective creative wealth.

Reflect

Why do I keep plying my craft despite failures and rejection?

Complete this sentence:
I keep developing my craft because I _____.

Day 92

Success, What Are You?

"If you've... written with authenticity and the authority of your own truth and infused your work with the joy of knowing that you are doing the work you were created to do, then you can count yourself successful, before the first copy of your book is sold and without comparing yourself to other authors and their successes."
— Judith E. Ingram, spiritual writer, from "Fan Into Flame Your Writing Gift," a presentation to the Siskiyou (CA) Writers Club

Up to now, these reflective odes to art has avoided much discussion about the pursuit of commercial success in your chosen field. What the world calls "success" is not within your sole power to attain. You do have full control of your dedication to your art. You've made a commitment to spend your time and energy mastering

your craft. You have *already* achieved success before you receive applause or sales.

Like most artists, you dream of fame and fortune. Understand, however, that idle dreaming about financial success may cast you into the depths of a long nightmare without hope of seeing the dawn. Dedicate yourself each day to labor in your field. In the end... you may have nothing tangible to show for it but a growing pile of rejection slips and lukewarm response.

Every truthful author admits to dreaming of opening the book section of the *New York Times* and seeing their latest novel or nonfiction work on the coveted list of best sellers. Wouldn't it be great to adorn your subsequent book covers and promotional pieces with that lofty label, "*New York Times* Bestselling Author"? You bet it would!

Opportunities do exist for dedicated creators. Commit yourself to learning the fine details of your craft in whatever ways you can. That said, if you've set your heart on making a living in pursuit of public esteem, your best mantra might be this, "Keep your day job until...." Always believe that whatever the odds against you, your ongoing dedication to lifelong learning and practice of your gifted craft put you, at least, in position someday to grab the "gold ring" on the artistic merry-go-round.

Reflect

What are my dreams of success in my field of the arts?

To what extent does dedication to perpetual learning match my desire to be the best I can be in my art?

If such dedication is lagging what decision might I need

to make regarding my career expectations?

*How might I already be sabotaging my prospects
of reaching the goals I've set?*

DAY 93

ART ENVY

"The term 'art envy' means... the feeling of resentment or sadness when viewing another artist's work, usually brought about by feelings of insecurity and inferiority. Basically, art envy exists when you're jealous of another artist's work. Is art envy destructive or useful? It can be both, but it's up to you to decide how you'll use your discontentment with your work. Which path will you take?"
— Sara Wagner, author and artist

Apply Sara Wagner's reflection to your own chosen art form(s).

When another artist's genuine talent reaps its reward, where does your mind go? "Wow! Good for that author?" Or the opposite... "Why isn't that me? My skill set matches, even surpasses that artist's." Most artists nurse that sort of negative response at some time and to some degree. Be assured, such talent-dulling negativity does

nothing to move you forward in your career. The opposite is true.

How do you feel when you see a book you've read and judged mediocre, at best, garner five-star reviews and gushing accolades in the book section of your local newspaper? Beware... allowing that kind of career-stunting envy to creep into your soul diminishes you... and your art. You do yourself and the world of art a *greater service* when you allow the success of others to spur you to hone your own craft with even greater zeal. Let the success of other artists motivate you to abandon your "pity tent" and strive to enhance in positive ways both your genre skills and your marketing outreach.

Reflect

Being honest with myself, when did I last envy another artist in my field for garnering kudos?

How committed am I to no longer comparing my success or failure to that of other artists?

What evidence do I find within myself that I can enjoy the success of other artists, without diminishing my own self-image and craft?

DAY 94

NO GOD? ...DARE YOU GO THERE?

"No God, no meaning. No God, no purpose. No God, no cosmic quality about us at all. We are simply sand flowing through a corruptible hourglass. But I cannot go there.

"To watch a painter paint and a musician play a symphony of their own creation, and a poet capture in 200 words the meaning of life, and a writer break open beauty and reasoning and possibility and meaning and throw it into the night sky, a blessing wherever it falls, is to know that we are here as Words of God."
— Sr. Joan Chittister, OSB (Order of St. Benedict), *An Evolving God, An Evolving Purpose, An Evolving World*

Sister Joan speaks the truth, acknowledging that artists and their works occupy a lofty position within the history of our world... and the universe. She invites you to recall a moment when a work of art in any form or

genre grabbed you by the scruff of your neck and asked, "Do you still doubt that the divine one (*by whatever name you call that presence*) has no independent reality and power in the universe?"

The art you create derives from a partnership between you and the divine artist. No one can take your place or Creator-Spirit's in that intimate relationship.

Reflect

Which statement in the above quote from Sr. Joan speaks to me the loudest? Why that one?

To what extent am I aware that my art is a sacred gift to the universe and no one can ever take my place in that intimate partnership?

If this is a new concept to me, how does it resonate within me?
Can I make it my own?

Day 95

The Fickleness of Success

"Success is peace of mind, which is a direct result of self-satisfaction in knowing you did your best." — John Wooden, former basketball coach at the University of California Los Angeles (UCLA)

As a gifted artist you have no guarantee of commercial success. You can only work hard to hone your skills, putting your offerings out there... then hoping, dreaming, fantasizing about the world's response to your "product." Surely you've read a beautifully written and truly satisfying contemporary book that received neither big sales nor prestigious awards. Like me, you may have written that book!

Consider your immediate, gut response when a fellow artist in your field reaps their deserved—or even undeserved—reward. Other less "successful" artists may ask, "Why not me? I work just as hard at my craft!" Deep-seated envy does nothing to move you forward on your career path... or your life. Certainly not your mental and

physical health. Your thoughts may go even further and wreak havoc on your gift and your dedication to it.

Let the success of others motivate you to take positive steps to further enhance your skills and promotional outreach. Also, be generous in sharing with others what you've learned. Above all, find and embrace that primal JOY you once found in your art. Measure your "success" as an artist by the deep satisfaction it brings you. As Coach John Wooden suggested above, "Success is peace of mind in knowing you did your best"—not that you became famous.

Reflect

Using joy as my standard of career measurement, where do I stand on the road to success"?

How hard is it for me to rejoice in the success of a fellow artist?
What makes it so difficult?

DAY 96

CREATING FROM THE HEART

"Art must be an expression of love or it is nothing.... If I create from the heart, nearly everything works; if from the head, almost nothing." — Marc Chagall (1887-1985), early modernist painter with artistic styles including a wide range of formats, including painting, drawings, book illustrations, stained glass, stage sets, ceramics, tapestries and fine art prints

One way to immerse yourself in your work is to leave your lonely practice room or computer and become active in a local arts community related to your genre(s).

If you have produced as yet unpublished manuscripts, screenplays, stage plays, poems, etc., do yourself a huge favor. Join a local and/or national organization related to your talents. Your involvement with a community of fellow artists will reap a number of benefits isolation cannot offer. Non-competitive exchanges with others in your field will both educate and inspire you to improve

and persevere, despite your current disillusionment and sense of falling short.

My involvement in a local community of fellow authors inspired me to become a much better writer than I was in 1996, when I gushed over my first commercially published novel, *A Love Forbidden.*

Month after month over the past two-plus decades, I've gained inspiration from my writing community... my "homies." I applaud their successes, support them in their disappointments, and receive the same benefits in return. In our monthly encounters we encourage our fellow writers to keep learning and writing... and to keep coming to the deep well of our gatherings.

Perseverance in striving is both the secret and the definition of "success" in all the arts.

Reflect

Who are my current artistic "homies"?
How often do we meet or otherwise communicate with each other?

If I'm a creative loner, how might I benefit from a community of artists?

In what ways do my fellow artists encourage me to keep learning and persevering when recognition and success pass me by?

How easy or hard do I find it to rejoice in fellow artist's successes?
How might I gain inspiration from their successes?

Day 97

Expectations

"Many times it feels like there is a tiny voice inside our heads telling us that something is going to fail, that we are not good enough to do something or that we will never get it right, because we have failed so many times in the past. Don't choose to listen to that voice! Don't let those words shape your expectations for the future.... Our expectations change the structure of our brain. Learned associations result in real physiological and cognitive outcomes. If these associations are positive, they are known as the 'placebo' effect. Yet the opposite is also true; thinking bad things are going to happen often allows bad things to happen—this is known as the 'nocebo' effect!"
— Neuroscientist Dr. Caroline Leaf, *Switch On Your Brain: The Key to Peak Happiness, Thinking, and Health*

Think about your current self-image as a creative person. When you look in the mirror of your soul, who and what do you see? A successful artist? Or a "pretender," one who has overreached and failed? Your answer points to where you are at this moment in your career.

Ask yourself, "How do I measure career success? By fame and financial gain? Or by my failure to achieve my dreams and goals?" Try measuring your worth with conviction that you have real talent. Say, "I am really good at what I do, but I can always learn more... get better." Be grateful for—and happy with—your talent without using financial gain and broad public recognition as your standards.

Dr. Leaf wants you to understand that your brain cells physically change depending on your answers to the above measurements. If your predominant self-image predicts failure in your field (the *nocebo* effect), you've trained your brain to expect failure. And your brain will obey by supporting your negative expectations.

Instead, the wise doctor urges you and all artists everywhere to alter your image of success and foster instead the *placebo* effect. If you do this daily, you are already on the road to genuine success.

Dr. Leaf precedes her reflection on "godly success" with this wisdom found in the first letter of St. John, Chapter 4, verse 1: "Beloved, do not believe every spirit. Rather, test the spirits to see whether they are from God."

Negative thinking offers you nothing useful, nothing godly. So, make no room for the *nocebo* effect in your creative life. That's a hard You-turn if you already self-classify as a pessimistic artist. But it might be your only way forward... for growth and happiness in your career and in your life.

Reflect

How ready am I to make a positive You-turn in my life as an artist, from the "nocebo" effect to a "placebo" effect?

What primary obstacle blocks my path to the "placebo" effect in my art?
How committed am I to removing that block?

What single step will I take today to begin that reconstruction process?

DAY 98

FACING FEAR

"Each of us must confront our own fears, must come face to face with them. How we handle our fears will determine where we go with the rest of our lives. To experience adventure or to be limited by the fear of it."
— Judy Blume, *Tiger Eyes*

Fear. It has a way of lurking around inside an artist's mind.

"Who do you think you are?"

"You're not good enough."

"You... an artist? You'll be a laughingstock."

These career-stunting voices abound in every creative person's life. Unfortunately, they can wear on your sensitive soul. The truth is that we "artist types" easily succumb to these self-spoken lies. Without their negativity, you will free yourself of the "not good enough" demons that may hold you back. Instead, affirm your talent every day. Whatever your work in progress, give it

your best effort. Resolve *today* to do your best work... and let your career take you wherever it goes.

True, life isn't always fair. You live in a creative world where anomalies occur... every week. You've seen tragically flawed artists garner fame and fortune. That's one of the great mysteries of a life in the arts. The ancient Romans had a saying that applies here, "*De gustibus non est disputandum.*" No, you can't argue over people's tastes. Instead take Judy Blume's wise advice... confront your fear. Meet it face to face. Expose fear as a poor excuse, incapable of taking you to the heights of your talent and desire. So, allow fear no power over you as you move forward with your creative work.

Reflect

In what ways does Judy Blume's advice strike close to home for me?

What is the primary excuse I use to prevent myself from achieving my goals as an artist?

What will I resolve to do about reversing any and all negativity lurking in my life... and my work?

DAY 99

THE ARTIST AS READER

"When we pray, we speak to God. When we read, God speaks to us." — St. Jerome (born 342/347, died 420), biblical scholar, the first to translate the Bible from Hebrew and Greek into Latin

Every artist must be an avid reader. The written word has so much to teach you about your life and the field of your art. In some branches of the arts, reading is essential. In the graphic arts, music, and other creative endeavors, the importance of reading may not seem obvious. Reading for knowledge and inspiration related to your gift and calling equips you to broaden your knowledge and boost your chances of succeeding in your chosen craft.

There is so much for you to learn from people who have succeeded in their craft and written about it. Often, they suffered rejection... even failure at some point in their careers. Like all artists, you need experienced guides to show you how to deal with disheartening failure

and find your way through the maze of artistic caveats and humbling mistakes.

In her nonfiction book, *Big Magic: Creative Living Beyond Your Fear,* Elizabeth Gilbert tells of using her own life experience and that of others to guide her on a safe path through the maze of misinformation abounding in all creative endeavors. In her down-to-earth narrative style, she sites example after example of how to avoid the creative life's hidden sand traps... and come out of the experience with your head on straight... enjoying a sense of peaceful balance within yourself.

Reflect

When was the last time I read a book of any kind?
What was it and what was it about?

What is the best book or article I've read on my craft,
one that inspired me to keep striving to grow and blossom
as an artist in my field?

NOTE: If you need some instant inspiration, read Elizabeth Gilbert's *Big Magic.*

Day 100

Essential Self-Affirmation

"Affirmations have the power to motivate you to act on certain things, help you to concentrate on achieving your goals in life, give you the power to change your negative thinking patterns and replace them with positive thinking patterns, assist you in accessing a new belief system, but above all, affirmations can reaffirm the positivity back into your life and help regain or increase your self-confidence." — Ryan Tanti, New South Wales, Australia

As one with a passion to own your artistic gifts and display them, identify yourself in one or more of the following scenarios:

• As a GRAPHIC ARTIST, I paint, sculpt, draw and thereby touch the hearts of those who view my work.
• As a COMPOSER, I transmit Creator-Spirit's beauty and compassion through my inner vision and gift of music.

- As a MUSICIAN, I channel the composer's vision, bringing joy to people's hearts, raising their spirits, enhancing their lives... even for a short time.
- As a SINGER, I add my voice to music, moving and entertaining my audiences.
- As a DANCER, I devote every sinew of my body to raising spirits, launching them heavenward.
- As a WRITER, I use language and the written word to transport my readers to new heights of insight about the human condition... and my own place in the world of art.
- As a POET, my verses offer light, life, and a way forward to soul-wounded spirits.
- As a PLAYWRIGHT or SCREENWRITER, I dramatize truth, challenging those who suffer from life-blindness and social/moral indifference... to discover new possibilities and moral insight.
- As an ACTOR, I hold a mirror to the world—and to myself.

Who am I? I am an artist, one who reveals and shares Creator-Spirit with the world.

Reflect

Who am I as an artist?

How do I use my art to instill beauty, insight, and newness of life through my offerings?

DAY 101

THERE'S PLENTY TO GO AROUND

*"There is a vision for my life that is greater
than my imagination can hold."*
— Oprah Winfrey

You who define yourself as an artist—whether amateur or professional, famous or unknown, beginner or lifer—arrived at a particular moment in life when you recognized within yourself some degree of giftedness. That "Aha!" moment changed your self-image... and your life. Another term for such a moment is *epiphany*.

In her wonderful book *Epiphany: True Stories of Sudden Insight to Inspire, Encourage and Transform*, author Elise Ballard defines "epiphany" (with a small "e") as a moment of great or sudden revelation. It may occur as an intuitive grasp of reality through something usually simple and striking. It may also come as an illuminating discovery, a realization, or a disclosure of some kind. Every artist rightly lays claim in some way to the spiritual phenomenon Oprah and Ballard describe.

Are all artists within the same genre equally gifted? The simple but true answer is, "No." In reality, though, your assessment and appreciation of art reveals subjective qualities largely dependent on your background and personal taste.

Let's explore the great "I AM..." of your creative life and mission. Which among the following first-person statements best describes how you perceive your artistic career?

- *I compose music*. Like the lead character in Andrew Lloyd Weber's *Phantom of the Opera*, I cast my net across the universe to snare the as-yet-unheard "music of the night."
- *I sing*. I offer my one-of-a-kind expression to composers' songs.
- *I play a musical instrument*... or two... or more. I add flesh and passion to a composer's notes.
- *I dance*, channeling Creator-Spirit's gifts and messages of love through the movements and rhythms of my body.
- I *paint*, I *draw*, I'm a *graphic designer*, interpreting divine beauty and truth within my chosen art form(s).
- I *write scripts* for stage, TV, and/or screen, scouring heaven and earth for the deeper truths of human existence.
- I *act*, giving flesh and spirit to the writer's carefully chosen words.
- I *write fiction and nonfiction books*, **short stories and articles**, weaving tales and truths in human words about interactions among unique people and objects populating our planet Earth... and the Universe.
- I am a *poet*. My verses sing the melodies of human language to move, inspire, and entertain minds and lift readers' and listeners' hearts.

• I ***live my art*** through strong and loving relationships, offering respect and intimate communion with those who watch, read, or listen to me. My art inspires both of us.

Reflect

Which of the above endeavors strikes closest to the gifts I have received from Creator-Spirit?

What feelings come over me when I read, see, hear and/or perform what my mind has envisioned and given flesh to?

When did I ever experience a life-changing moment of "Now I get it!"

How has that epiphany changed my life... my art?

ABOUT THE AUTHOR

A native of the beautiful Southern California beach city, Santa Monica, I now reside in the San Francisco East Bay area. I began my career in the arts at the age of seven, along with my sister, Natalie. We did non-speaking bit parts in movies requiring Italian-looking kids. I should be honest about Natalie's sole speaking part in the "Hunchback of Notre Dame." She ran down the street with a frantic mob screaming, "The hunchback is coming!"

Natalie later used her magnificent coloratura voice to pursue a career in grand opera. Our talented younger sister, Toni, has sung and acted with Los Angeles area theatre groups. By my teens, I had veered onto a different road in academics and spirituality. Over the years I have done a great deal of writing and teaching, mostly on Christian themes. I didn't get the book-length bug until my forties. Once the muse struck I couldn't stop and have now written over a dozen books, both fiction and nonfiction, published through commercial and independent publishing channels . My interests and topics range from biblical themes... to the arts... to steamy romance novels and poetry.

I invite you to visit my blog at
www.wisdomoflesmiserables.blogspot.com
and my website at
www.alfredjgarrotto.com

You can also find me on Facebook at
AlfredJGarrottoAuthor.
I hope you will drop by.

ACKNOWLEDGMENTS

In the late 1930s, my dad, Joseph W. Garrotto, worked as a night janitor at the famed MGM Studios in Culver City, California. At times studio photographers invited him to pose as they practiced their lighting techniques. As a child I treasured those black-and-white images that made him look like a real Italian movie star. It was during this period that Dad got the screenwriting bug and produced a script, "Red Snow." I still have it in my possession and treasure it. Unfortunately, his script never made it to the big screen. To my knowledge, my dad never wrote for publication again.

Along the way, he must have passed some bits of writing DNA on to me. I've wondered over the years, as a published author and manuscript editor... "Am I living his dream?" So, whatever talent I may have in that area of the arts, I say, "Thanks, Dad."

Again I want to express my gratitude to Father Brian Joyce, the late pastor of Christ the King Parish, Pleasant Hill, CA. One early summer day in 2016, we crossed paths in the busy parish office. I told him I was writing a book, *The Soul of Art,* for creative people engaged in the arts. He said casually, "Only the artist can see in the dark" and left the room.

I thought, "Wow! That's what my book is about." The next time I saw Brian, I asked whom he had quoted. He

looked puzzled. Apparently, it had come out spontaneously! He had no recollection of ever having said it. But I have not forgotten.

Later, I searched the Internet for those exact words in hope of finding their source. Nothing! Another Google search in 2023 brought the same result. From that experience, I came to believe in divine, on-the-spot communication—a spiritual ad hoc inspiration through the voice of a human messenger.

Again, I want to thank the uber-talented Natasha Middleton for her cover endorsement. I'm humbled by her glowing response to this book. In addition to her skilled direction of a rising ballet company, she has won many awards for her short film, "Dissension Within."

I also owe so much to my "homies" in the Mount Diablo Branch of the statewide California Writers Club. Not because I've neglected to pay my annual dues. No, I'm indebted, because they've honored and nurtured my creative gift. They've shown me what it means to be a professional writer, as well as what it takes to believe in myself and stay positive in today's extremely competitive publishing market. For the past 27 years they've modeled both the joy and the angst of the writing life.

Thanks also to talented artist Douglas MacWilliams Lawson for allowing me for a second time to use his remarkable artwork, "On Dancing Light," for my cover art.

And to my wife Esther. Human words fail to express my love and gratitude for her constant support.

Books by Alfred J. Garrotto

<u>Nonfiction</u>
The Soul of Art

The Wisdom of Les Misérables:
Lessons From the Heart of Jean Valjean

<u>Fiction</u>
Inspector Javert: at the Gates of Hell

Bishop Myriel: In His Own Words

There's More: A Novella of Life and Afterlife

The Saint of Florenville: A Love Story

I'll Paint a Sun

Circles of Stone

Caribbean Tremors Trilogy
Down a Narrow Alley

Finding Isabella

A Love Forbidden